New England Icons

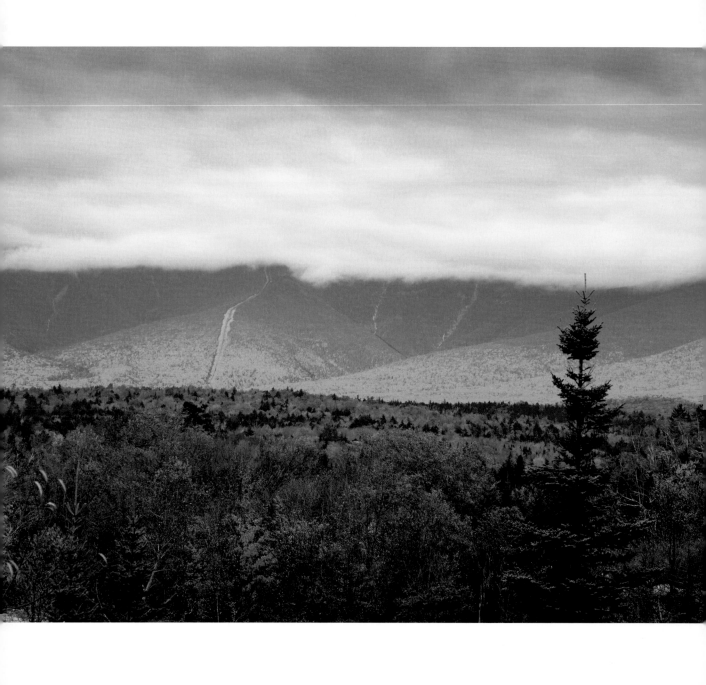

New England Icons

Shaker Villages, Saltboxes, Stone Walls, and Steeples

Bruce Irving

Photographs by Greg Premru

THE COUNTRYMAN PRESS

WOODSTOCK, VERMONT

Library of Congress Cataloging-in-Publication data have been applied for.

New England Icons
978-0-88150-927-4

Book design and composition by Eugenie S. Delaney
Maps by Paul Woodward, © The Countryman Press

Published by The Countryman Press, P.O. Box 748, Woodstock, VT 05091
Distributed by W. W. Norton & Company, Inc.,
500 Fifth Avenue, New York, NY 10110

Printed in the United States By Thomson-Shore, Dexter, MI

10 9 8 7 6 5 4 3 2 1

To my parents

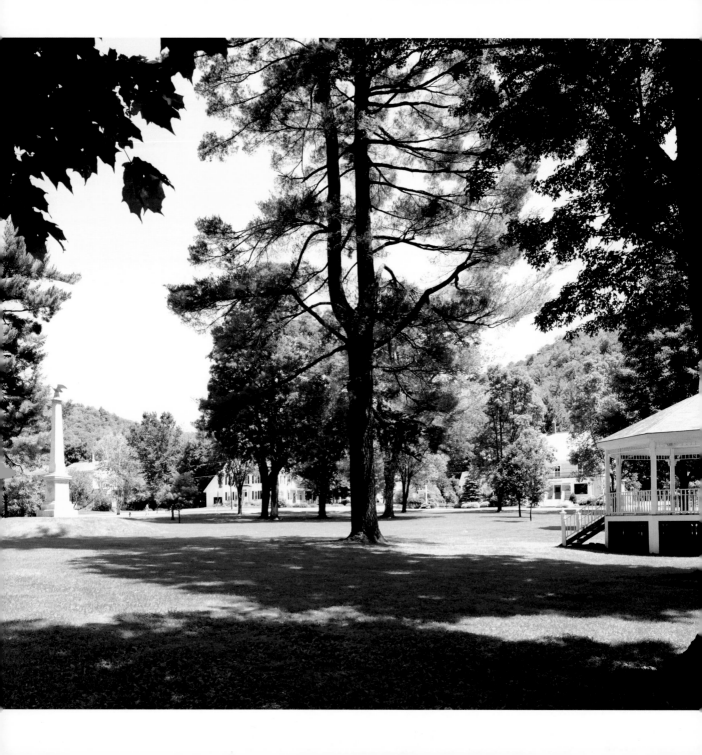

CONTENTS

FOREWORD

I'VE TRAVELED ALL OVER THE COUNTRY, and often I'm asked what my favorite place is. As wonderful as some of my visits have been to other parts of this beautiful nation, I'm always happy to return to New England. The history, the architecture, the seasons, and my family and friends have always made it a special place for me—it's my home. I was born in Rhode Island, raised and educated in Massachusetts, and after college lived in both Vermont and Maine. I've enjoyed New Hampshire and Connecticut during family outings and vacations. So as a lifelong New Englander, I was immediately drawn to the very idea of Bruce's book.

Not a day goes by without me sighting one or more of these icons. Sometimes the fast pace of our lives causes us to take what's right in front of our eyes for granted; these essays have made me pay more attention to my surroundings and have brought back special personal memories of my New England life.

Growing up, I would spend summers at a lakefront cottage my father built, swimming, fishing, and boating. The cottage had a kerosene heater, so even though we would shut the water off and

winterize the place, we had a way to keep warm when we came back to skate and go ice fishing. I still have that ice-fishing equipment and, even though I have not used it in years, every time I see a frozen pond it brings back memories of pulling our sleds across the ice with a box of tilts, tools, and live bait onboard. When my father found just the right spot, he would take a giant chisel he had made (no power augers in those days) and cut several holes in the ice. We would set a tilt in each hole after baiting the hook. Waiting for the red flag to pop up and let us know a fish was on the line got pretty boring, so it was time to skate. My sister and I were not great skaters but we sure had fun trying to perfect our technique while keeping an eye out for a tilt displaying a red flag. When one did pop up, we would race to see if we had made a catch. At our lake it was usually a yellow perch or a pickerel. We'd release the bony pickerel, but perch would end up on the dinner table. After a day of skating, fishing, and eating fresh fish for dinner, everyone was assured a good night's sleep.

You always know that the New England winter is just around the corner when wood smoke is pouring out of chimneys, filling the neighborhood with that familiar smell. My parents used their fireplace frequently, mostly on winter weekends. I'm not sure if they were trying to save on the heating bills or if they wanted to create a cozy atmosphere, but it sure felt good. As kids, my sister and I would lie on the floor in front of the fireplace playing games for hours. It was also the background for just about every family group photograph. When I designed my own house, I got a little carried away with fireplaces and specified four. They are a Rumford design, which throws a lot of heat into the room, rather than up the chimney. It's been seventeen years since I moved into this house and I have to admit, the only fireplace we use is the one in our great room. I started the first fire in that fireplace when I was building the house to provide temporary heat. Today we use it to add a little extra warmth and ambience to the nearby seating area. A few days ago I stacked over a cord of firewood. It should keep that Rumford roaring and us cozy for several more years—and I'm very thankful that I don't need the twenty to thirty cords a year Bruce writes about the typical eighteenth-century New England farmhouse consuming.

Given my line of work, I'm always going to the hardware store, and fortunately I have an excellent one nearby. Like the ones in this

book, it's a family-run affair with an incredibly friendly and knowledgeable staff. They usually have what I need, and if they don't, it's more than likely they'll get it for me. Even though the store is modern, it reminds me of the place I used to go to with my father. He was a carpenter by trade and had also been a mechanic in the army during World War II, so there was nothing around our home he couldn't fix. I would often go with him to get supplies at the local hardware store, where he would be greeted like an old friend as we walked through the door. They would ask, "What do you need today, Louie?" After a short conversation, the clerk would be off to get the necessary items. I on the other hand would wander around the store's wooden floor looking at tools and the endless supply of hardware and fasteners, not wrapped in plastic like today but piled in bins or neatly hanging on the walls or stacked on shelves. There was a glass-cutting table; there

were oak cases with dozens of drawers filled with various items, sometimes labeled, sometimes not, but the clerk knew exactly what was in each one. Need a torn screen repaired? No problem—it would be ready the next day. Stores like that are rarer today, but I'm happy to say that mine is a close second, and I'll bet the ones described in this book are in the running, too.

I have memories associated with many of the other icons here, but what I love the most about this book is how Bruce has presented a perspective of these places and things from their origins to the present day. Having worked with him for many years, knowing his attention to detail and accuracy, I expected nothing less. Whether you're a native or a newcomer, a resident or a visitor, this is an inspired collection of stories to be enjoyed by all who love New England.

—Norm Abram, MASTER CARPENTER

INTRODUCTION

I WAS LUCKY ENOUGH TO BE BORN in Darien, Connecticut—
a nice, leafy town to grow up in. My folks (both Bay Staters—
Mom from Adams, Dad from Somerville) weren't rich, but we
did have access to my grandparents' summer cottage in the Berkshires
in Western Massachusetts. We'd pack up the station wagon on broil-
ing Friday afternoons and drive up Route 8 to the old place in Hins-
dale. It was on a beautiful little reservoir, and I learned to swim there.
If it rained, we'd visit museums and shops in places like Pittsfield and
Williamstown, where I'm quite sure the ideal of "college" became
lodged in my head. I ended up going to Williams College in the early
'80s and had a wonderful time.

We also spent time in Kennebunk Beach, Maine, where my step-
grandmother lived. I love cold New England ocean water because of
those visits—a picture from one of my first shows me being lowered,
to my consternation, into an icy tidal pool.

But I swear I'm not parochial. I lived in London and traveled
all over Europe in my college years; after college I spent three
years in Japan and saw lots of Asia. Those were adventures that
stuck with me, even as I moved from Japan to Cambridge, Massa-

came when I was hired to work on the television show *This Old House*, home of some great New Englanders, including Norm Abram.

Thanks to the show, I saw more of the world, living for (winter) months in places like New Orleans, Santa Fe, Miami, Savannah, London, Honolulu, and the Napa Valley while overseeing our away-from-Massachusetts projects. But like *This Old House*, I always came back to New England, to live again in the inimitable climate, with the inimitable natives, surrounded by all the things that make this place so wonderfully different from everywhere else.

chusetts, where I've lived ever since.

In Cambridge, I met my wife, a far more dyed-in-the-wool New Englander than I, with roots going back to the *Mayflower*. And if that wasn't good enough, another stroke of luck

This book is about some of those things. Whether you live in New England or love to visit, I hope you enjoy it.

ACKNOWLEDGMENTS

WITHOUT JILL CONNORS, this book wouldn't have been possible. As the founding editor of *Design New England* magazine, Jill had the idea to start a column about the things—especially those in the built environment—that make this part of the country special. We'd known each other at *This Old House*, she thought I could do the job, and I thank her for the opportunity.

Under Jill, and now under my wonderful editor Gail Ravgiala, I have looked forward to each article as a kind of dream research paper. Deep dives into subjects that fascinate my inner history and architecture geek—what more could I ask for?

For educating and guiding that inner geek over nearly two decades, I thank Russell Morash, creator of *This Old House*. He's a Yankee through and through, with a deep respect for the craftsmanship and history behind all the great structures we covered on the show. Russ, Norm Abram, and the rest of the *TOH* crew taught me to see the wisdom and qualities in work well done.

Always helpful and always knowledgeable, Sally Zimmerman at Historic New England was my go-to gal time and again. If she

didn't have the answer I was looking for, she knew someone, or several someones, for me to ask. Thank you, Sally.

I met photographer Greg Premru way back in 1996, when he was shooting the Nantucket project for *This Old House* magazine. I've admired his work ever since and was thrilled when he agreed to travel all over New England to capture the perfect, iconic images we needed. His eye is superb, and I thank him for lending it to this book.

Finally, my heartfelt thanks go to my wife, Debby, who has read every essay I've written, providing feedback, suggestions, and, most of all, loving support. She's my kind of icon.

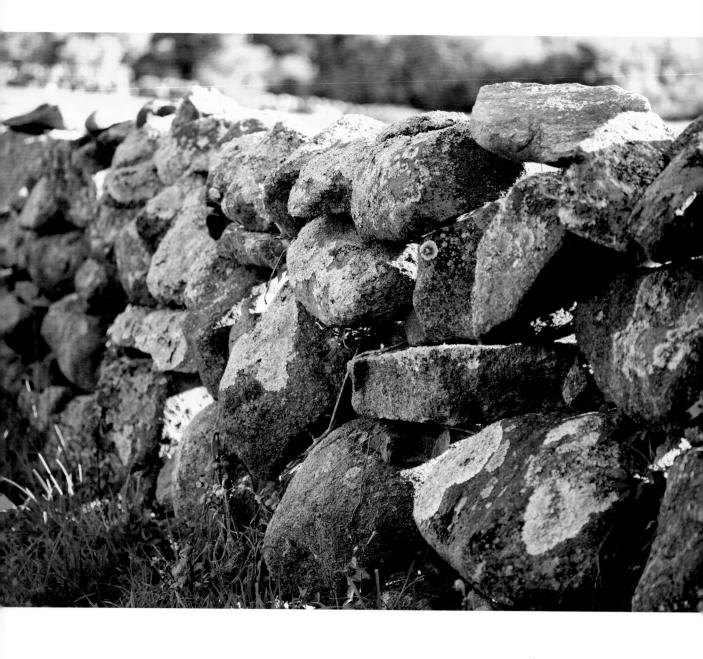

Stone Walls

IT'S HARD FOR NEW ENGLANDERS to conceive of their beloved stone walls as something less than beautiful, functional folk art, as essential to the landscape as maple trees and village greens, lichened and mossy testaments to the blood, sweat, and tears of their forebears. But, really, their origins are not nearly as poetic. Their story starts long before colonial times, at the beginning of a set of geological events that accounts for New England's preeminence in the world of stone walls. The Stone Wall Initiative, a not-for-profit group in Storrs, Connecticut, tells it this way: Tens of millions of years ago, ancient mountains eroded away, which took weight off the bedrock below, causing the top mile or so of bedrock to expand slightly and rupture into myriad tightly nested pieces. When Ice Age glaciers arrived, they plucked up these boulders, grinding them down and leaving, upon their retreat, a muddy, sandy, stony mess called glacial till. Over fifteen thousand years, first tundra, then forest built up a rich layer of black soil and mulch over the till; it was at its thickest when the astounded and delighted colonial farmers arrived. That soil would make for good planting, once the trees were cleared. And that's when the trouble began.

Clearing trees exposed the soil to the plow—and to the elements. Erosion and freeze–thaw cycles began to work in concert to reveal the glacial legacy lurking in the subsoil: stones, billions of stones. To the increasing annoyance of the once-happy farmers, each spring brought a new crop. The only thing to do was lug or trundle the damned things off and dump them. The least amount of effort assured their position in rows along field edges, none more than waist-high, the maximum easy lift.

Time passed; the land was more intensively used, and the stones kept coming up in the spring—some farmers blamed the devil. But stone walls began to serve as more than dumping grounds, and practicality and art became intertwined. There were new boundaries to mark—look for a wall where there's little prospect for agriculture, on a steep hillside perhaps. There was livestock to corral—sheep especially were a challenge because they like to climb, so some farmers built extra-high walls, topped stone walls with wood fencing, or built "lace walls," delicate-looking single-thickness affairs that taper upward as the stones get smaller, often with visible gaps between. They shed stones easily, which keeps the sheep off

them. And as the farmers' prosperity grew, there was pride of ownership to show—they took extra care to set the walls tightly, and used capstones for a neat appearance and protection from the elements. Some wall builders even dressed the stone faces for a smooth look.

There were once some 250,000 miles of stone walls in the Northeast, enough to stretch to the moon. Perhaps half of those survive, their epicenter generally sited in a fifty-mile radius around the meeting point of Massachusetts, Rhode Island, and Connecticut. Three towns rich in walls are Little Compton, Rhode Island; aptly named Stonington, Connecticut; and the Shaker village in Canterbury, New Hampshire.

And if you want one of your own, you won't be alone. Landscape architect Paul Maue of Andover, Massachusetts, says that a stone wall is one of the first things most clients mention. "They know they're expensive," he observes, "but they're willing to sacrifice elsewhere to get one." Traditional dry-wall construction is increasingly rare, according to landscape contractor Roger Cook, of Burlington, Massachusetts: "It's slow and painstaking, which costs money. Most walls these days are built with concrete, which is much faster and

requires less craftsmanship." Even walls that appear to be dry-laid may have concrete at their core. But wet-laid construction comes at a cost: Since such walls don't drain water as well as dry-laid walls, extra care must be taken with their bases. "They should have a concrete footing or at least three feet of gravel beneath," Cook says. "Otherwise they'll heave out of the ground over time." Seems like the devil is still at work.

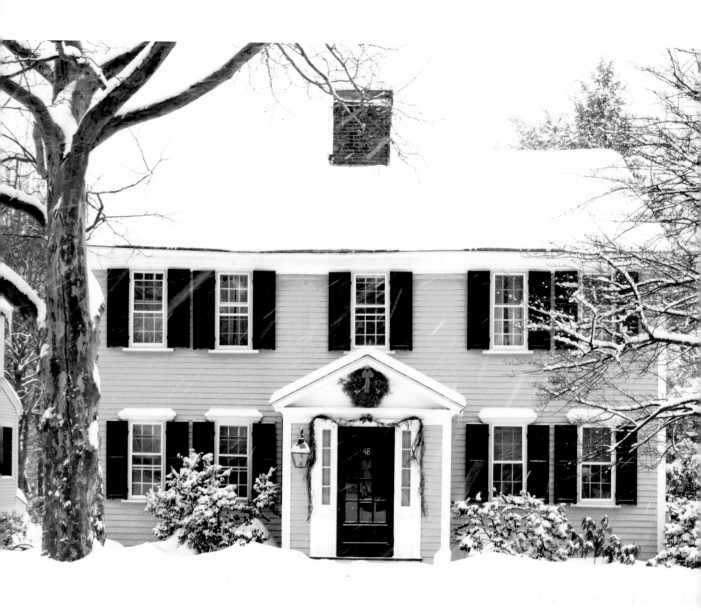

Center-Chimney Colonials

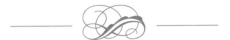

HERMAN MELVILLE, in his 1856 short story "I and My Chimney," drolly memorializes his campaign against his wife's desire to modernize Arrowhead, their house in Pittsfield, Massachusetts, by getting rid of the center chimney, the house's "one great domineering object." His house was constructed, Melville fondly observed, "not to my wants, but to my chimney's, which, among other things, has the centre of the house to himself, leaving but the odd holes and corners to me."

For many, like Melville, calling a center-chimney Colonial house home meant embracing the hefty pile of bricks at its heart.

The ubiquity of such houses in New England was noted by none other than George Washington, who, on his 1789 presidential tour of the region, wrote in his diary that there was "a great similitude in their buildings, the general fashion of which is a chimney . . . and door in the middle, with a staircase fronting." That wasn't the norm in his Virginia, nor elsewhere in the States, where chimneys were found on or near a house's end walls.

The form, brought across the ocean by the very first English settlers, was already more than 150 years old when Washington

took his tour. Trained carpenters and masons, most from the East Anglia and Kent regions near London, employed the center-chimney style their forebears had long been building, erecting a sturdy frame of oak or pine first and then laying up the chimney inside it. At first they used bricks shipped from overseas, but— as soon as colonial kilns were up and running— they switched to those made locally.

The center chimney proved to be a most useful import. As a heating plant, it was a terrific check to the long, severe New England winters. A huge mass of bricks hosting multiple fireplaces and run through with flues carrying hot gases, it acted as a giant thermal mass, holding heat and radiating it outward from the core of the house. Unlike chimneys on the outside walls, it didn't have to fight hard against the heat-sucking outdoor air. And with at least the cooking fire going at all times, the therms kept coming, never allowing the mass to cool.

Nonetheless, the sheer amount of firewood needed to heat a typical eighteenth-century New England house boggles the mind. Farm accounts and other estimates put it in the twenty- to thirty-cord-per-winter range, equal to about an acre of forest and, at four by four

by eight feet per cord, enough to form a cube fifteen feet on a side. Think of that the next time the oil delivery truck stops by.

Central chimneys were more than heating appliances, of course. The cooking fireplace, with its pot cranes, trammels, and built-in bake ovens, fed the family, and it often had an upstairs adjunct in the form of a meat smoker. Found in second-floor closets or behind little doors halfway up the front stairs, these were brick chambers opened to the main flue, with a small hole down low to let in passing smoke and a hole up top to let it rejoin the flue. The upper hole often had a plug of some sort to regulate the amount of smoke being trapped. Inside were iron or wooden hooks to hold a joint of beef or side of bacon. Restoration mason Richard Irons of Limerick, Maine, recalls finding a chalked note on the inside of one smoker in a 1750 home in Kennebunk, Maine. It marked the day that a certain piece of mutton went into the chamber and when it was scheduled to come out, three days later.

But all was not perfect. Architectural conservator Brian Powell of Building Conservation Associates in Dedham, Massachusetts, says center chimneys "were a great idea, and a terrible one," the latter because of the way they

clogged up a house's floor plan and circulation. The very volume and centrality that made for good heating got smack in the way of other important functions, like passing through the building, getting upstairs, and allowing privacy in bedrooms. Powell should know—he lives in the circa-1681 Cooper-Frost-Austin House, a center-chimney building that is the oldest home in Cambridge, Massachusetts.

The problems start at Washington's "staircase fronting," where the space between the front door and the stairs that hug the chimney is barely enough to be called a hallway. (Melville called it a "square landing-place.") Taking off coats and hats, not to mention muddy or snow-covered boots, was enough of an inconvenience that enclosed vestibules soon sprouted in front of homes to give a little extra entry space. Upstairs, access to the rear bedchambers was often by way of the front ones. "These folks had a tolerance for walking through private rooms much greater than ours," says Powell.

So no surprise that as heating technology improved (smaller, shallower fireplaces were found to throw heat better, for example), people's desire for a better floor plan won the day. Owners of Georgian and Federal homes gloried in their central halls, which often had grand stairways and private bedrooms, all made possible by the migration of the chimneys to the ends of the building.

For those living in their old central-chimney houses, the choices were putting up with it, modernizing the fireplace by shrinking it, or removing the thing entirely, a major piece of surgery. While Melville ultimately persuaded his wife to take the first option, Louisa May Alcott's father, Bronson, took the last, "splitting" the first-floor chimney of the family's home in Concord, Massachusetts, to make way for a central hall.

Still, much endures from those early days of English carpenters and masons. Drive through any suburb, down any cul-de-sac, and you'll spot center-entrance Colonials in multitudes. Just don't look for center chimneys—they've gone the way of Melville's whaling ships.

Hardware Stores

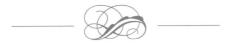

NEW ENGLANDERS who grow up with a good hardware store in town have memories of visits with fathers or grandfathers (and less commonly mothers or grandmothers), of narrow aisles crammed with tools and things whose name and use were wondrously obscure to a child, of gruff but all-knowing clerks at the counter, of adult conversations about projects and products, of worn wooden floors and a distinctive smell that came from key grinding, fertilizer, wood, and turpentine. It was a place of possibility—think of all the things you can make with this stuff!—and practicality; without it, the town it stood in couldn't have been built or maintained.

Despite the onslaught of big-box retailers, New England's small, independent hardware stores continue to survive and even thrive. Their advantage over such competition? "We sell people from around here what they need and what they want," says Bill Round, the second-generation owner of Round's Hardware in Stoneham, Massachusetts. "I stock live fish—shiners, for bait—because folks kept asking for them. Guys who run stores near the ocean carry ocean stuff like chain and stainless-steel fasteners, guys near the mountains

carry mountain stuff, guys near farms carry farm stuff. A big box 'sells to plan': If they've sold out their allotted fans for the season and you go in on a hot day, they'll try to sell you a snow blower."

Early America's storekeepers served small markets and thus stocked a broad range of goods, from groceries to drugs to dry goods to hardware. In his book *Travels in America*, published in 1809, Irish writer Thomas Ashe reported: "These shopkeepers are obliged to keep every article which it is possible that the farmer and manufacturer [artisan] may want . . . both a needle and an anchor, a tin pot and a large copper boiler, a child's whistle and a pianoforte . . . a glass of whiskey and a barrel of brandy."

That business model still holds for retailers like John Fix III, a third-generation owner. "Products build up from sitting on shelves, and if you have room for it, you keep it," he says. "Rockwell stopped making its 315 circular saw back in the '70s, but we've still got parts for it somewhere out back. Guys come in looking and you sell them a part like that for the original price—twenty-five or fifty cents. You hope the person will be happy and come back when they need something bigger,

like a Weber grill." And while whiskey may no longer be available, Fix does stock beer-making ingredients.

Requirements for an old-fashioned hardware store vary. For Stephen Reid, who runs a goat farm in Brookfield, Vermont, it's location and layout: "They need to be in a two- or three-story downtown block, so the basement and upper floors can be full of stuff that dates back a century or so." One of his favorites is in Rochester, Vermont, and is known locally as "the Hardware." Not surprisingly, many say the store must be family-owned and -operated. "We live, eat, and send our kids to school in this town, and we know about things a corporation just can't, like the kind of window hardware the 1940s apartment buildings nearby use," say Fix. At Vanderhoof Hardware in Concord, Massachusetts, customers are served at the counter by twenty-three-year-old Thomas Vanderhoof, the great-great-grandson of the founder.

Buying co-ops, member-owned organizations like True Value, Do It Best, and Ace, pool purchases to obtain volume discounts. Discounts aren't as large as at big-box stores, but are good enough to compete. Co-ops help small owners cope with the dizzying array

they must stock. Owner Scott Vanderhoof, Thomas's uncle, says, "The inventory sheet of 1904 was just one page, and all the goods fit on one side of the sheet. Now we've expanded to over thirty-three thousand items"—all in a thousand-square-foot store. Co-ops also take a proactive interest in their members' family-succession business plans.

When it comes to service, the new generation works as hard to satisfy a new kind of customer—one with plenty of options and little time—as it does to know the right spring hinge or tank flange for the job. This wasn't always the case. Russell Morash, creator of public television's *This Old House*, started the show in part to demystify the insular world of the old hardware store.

"When I was a boy," he says, "my carpenter dad would send me down to the local hardware place to get odd bits of things he needed. In those days, before 'blister packs,' you could buy a single nail, a screw, a jar of kerosene, or an escutcheon plate in a store managed by a surly character with little patience for those of us who didn't know exactly what we wanted. 'Just what kind of *es-cut-cheon* plate did you want, Sonny?' he'd snarl. With an audience of other customers listening, he would then rage at me for wasting his precious time. Some difference from today's home centers, where 'greeters' practically tackle you in the parking lot, so eager are they to tell you about 'today's specials.'"

Nowadays, traditional hardware stores dole out a lot less snarl but the same good information. Stepping into one of these New England survivors, a kid could get inspired—or at least learn something about escutcheon plates.

Shaker Villages

I F THE SHAKERS LANDED in America today, one wonders how they'd keep the hordes back from the sign-up table. What's not to like about equality of the sexes, a green approach to building and land stewardship, "locavorism," pacifism, and a world-class design aesthetic based on function over form?

Officially they were the United Society of Believers in Christ's Second Appearing, but commonly were called Shakers, a moniker derived from the way they would shake as sin "left" their bodies. They came from Manchester, England, in 1774, led by Mother Ann Lee, an illiterate factory worker married (against her will) to a blacksmith and possessed of the belief that she was the Second Coming of Christ, in female form. She and eight followers, including the husband who would soon desert her, landed in New York City, later moving north to a spot near Albany called Niskayuna, where they founded a community open to like-minded seekers of spirituality.

Mother Ann died in 1784, but the Shakers grew, establishing new communities at a blistering pace, starting with Hancock,

Massachusetts, in 1790. Nineteen more villages came in rapid succession, including New England locations in Harvard, Shirley, and Tyringham, Massachusetts; Enfield and Canterbury, New Hampshire; Enfield, Connecticut; Alfred, Maine; and New Gloucester and Poland, Maine, where the Sabbathday Lake community straddles the two towns.

Today there are just three practicing Shakers (all live at the Sabbathday Lake compound), but at Hancock Shaker Village, the principles upon which the sect was founded may see a rebirth in the form of new construction. Although the village is a popular tourist attraction, Hancock's president, Ellen Spear, says: "With half of our budget reliant on fundraising, we were facing a long, slow death. We realized we had to monetize the twelve hundred acres we have, and the question became, 'What would a new community, grounded in Shaker thought, look like?'"

Architect Jeffrey Klug is working with the village to come up with an answer in the form of a master plan. An admirer of Shaker architecture and craftsmanship, Klug describes their work as possessing "a tautness that comes from rigorous geometry." Spare, unadorned, and harboring a quiet beauty, Shaker style reflects members' belief that their purpose was to create a heaven on earth, that God dwelled in the details of their work and the quality of their craftsmanship, and that making something was in itself an act of prayer. Creating a chair, a bowl, a bonnet, or a building meant communicating with God, so one had better strive for perfection.

"Beauty rests on utility" was the Shakers' credo, and the guiding principle became "Let it be plain and simple, of good and substantial quality, unembellished by any superfluities which add nothing to its goodness and durability." With that in mind, the Shakers worked within established architectural types, embracing the clean forms and symmetries of the Federal and Greek Revival styles as suitably free of frippery. Shaker carpenters were charged with building entire villages, and the harmonious compositions they created embody a serenity and grace that make a deep impression on visitors, then and now.

The original villages had major buildings—meetinghouse, business office, and elders' dwelling—centrally located, with subsidiary "family" dwellings (for groups of thirty to a hundred unmarried men and women and adopted children) and workshops arranged

along a main road. Early buildings were wood and usually painted straw yellow, except for the meetinghouse, which was mandated as white. Brick buildings came with increasing prosperity, and some villages featured astounding edifices: the six-story office in Harvard; the round stone barn in Hancock; the two-hundred-foot-long barn in Canterbury, with its polished chestnut beams. Buildings used by both sexes had separate doors and staircases, to prevent temptations of the flesh. Because dance was crucial to the religion, meetinghouses had great, uninterrupted main floors, made possible by technologically advanced framing systems.

In the early nineteenth century, a time of religious ferment that later would be called the Second Great Awakening, people responded to the Shaker message of direct communion with God, communal living, and the possibility of divine purification here on earth. However, there is one tenet of the Shaker religion that might serve to shorten today's sign-up line: celibacy. Perhaps because she had eight preg- nancies resulting in four stillbirths and four children who did not survive past age six, Mother Ann Lee preached that holiness could be attained by giving up sexual relations and by confessing all of one's sins. Those are presumably not principles that the residents of the proposed Shaker-inspired community in Hancock would be expected to embrace.

How the Hancock of the twenty-first century will take shape is still being worked out, but current plans include housing, a small hotel, two restaurants, and manufacturing and showroom space for artisans and farmers. For his part, Klug says the buildings will be of a contemporary design, inspired by the nearby originals. "There are many moments where I look at some little detail there and say 'Aha' and feel like I'm speaking with someone across a century."

"We'll power it with renewable energy," says Spear, "and it will be a place for people to experience, in our time, what it means to live a principled life."

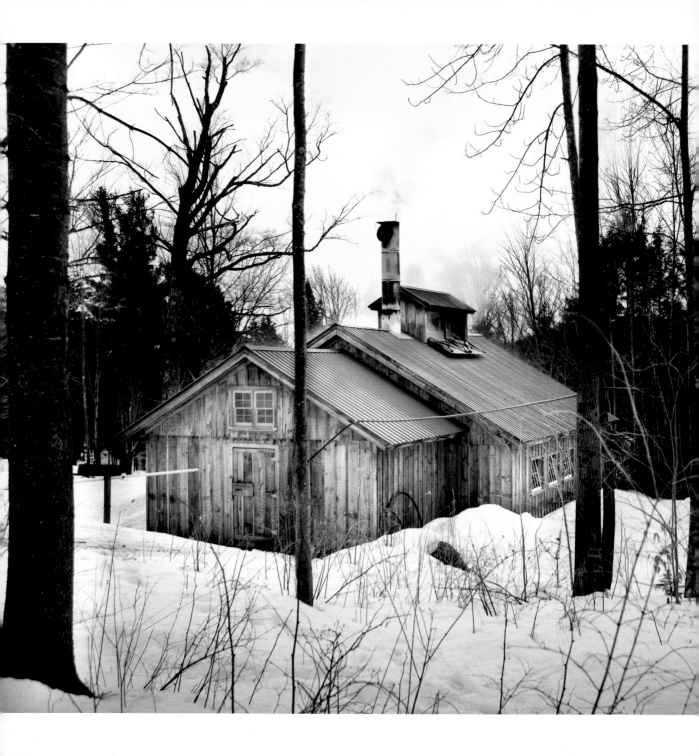

Sugarhouses

THE NEW ENGLAND SUGARHOUSE has the same organic, natural qualities as the stuff that gets produced inside it. Maple syrup was, and is, tough work, and there's never been time for, or interest in, crown moldings and decorative soffit details for the improvised buildings where it's made. Simple and unaffected, sugarhouse design comes from farmers whose architectural skills were rooted in the field rather than the academy and whose aim was to get a job done with a minimum of fuss and waste.

However, maple sugar existed long before there were buildings devoted to its production. Early Native Americans concentrated the maple tree's slightly sweet sap through boiling, or by freezing it and removing the ice. For the colonists, syrups and sugars heated in iron pots became an important alternative to expensive imported cane sugar. Later, maple products became popular with abolitionists: The 1803 *Farmers' Almanac* exhorted, "Make your own sugar and send not to the Indies for it. Feast not on the toil, pain and misery of the wretched."

The egalitarian nature of husbanding and harvesting maple sap

in the forest made it a perfect commercial crop for independent-minded Yankees. Whether the locals call it a sugar wood or a sugar bush, a grove of maples becomes the hub of activity at the earliest stirrings of a New England spring. Warm sunny days alternate with freezing nights to draw sap (about 98 percent water and 2 percent sugar, minerals, and even vitamins) up through a tree's circulatory system and out a sugar maker's taps. Beyond science, though, there is magic in the awakening woods. "There is something about them that pulls like a magnet," noted Muriel Follett in *A Drop in the Bucket*, her 1941 memoir of sugaring in Vermont.

"A sap run is the sweet good-bye of winter," the nineteenth-century naturalist John Burroughs observed. "It is the fruit of the equal marriage of the sun and the frosts."

In sun or frost, the task remains the same: Sap needs to be boiled down, and syrup must be delivered to market. In the old days of collection by heavy buckets, it made sense to haul the least amount of liquid the farthest distance. That's why early sugarhouses were built where the sap was, deep in the woods, their remoteness necessitating the kind of "toggled-up and patched-together" construc-tion seventh-generation Vermonter and sugar maker Burr Morse remembers.

"Those old farmers couldn't afford or justify dragging a carpenter into the woods," he points out. "They just built them as they could." What they needed was shelter for their evaporator—an arch of bricks forming a firebox under a set of shallow metal pans. What they built were simple post-and-beam rectangles, with steep roofs to shed snow, rough vertical siding, and an open cupola to let out the resulting copious steam. (Morse cites this fact of sugar making as another reason not to get too fancy with the construction: "Steam is no friend of finish carpentry.")

The ideal spot was on a hillside, so that a sap tank could be installed above the building, with gravity feeding the evaporator inside. An open porch would hold the firewood; a bunk would hold the exhausted farmer. As W. T. Chamberlain wrote in the March 1870 *American Agriculturalist* magazine, "You will sleep soundly after gathering 30 barrels of sap." But there was a rough romance in the work, too. When the sap was running strong, boils continued through the night, under crystal stars and "amid the silent trees," as Burroughs wrote. "And," Follett recalled, "there is always the crackling

sound of the wood fire, the soft hissing of the boiling sap and the mingling smells of the smoke, the sap and the damp earth outside."

Early on, sugarhouses sat on flat stones and had wood shingles on their roofs. Concrete footings and floor slabs came later, as well as corrugated metal roofing to prevent sparks from burning the whole affair down.

The framing and siding were usually hemlock, "big-around trees that are easy to make lumber from," says Morse. "It's not a pretty wood, but it gets the job done." There were no paints or stains this far out in the woods—the structures were left to weather. And so they did, turning a dark brown and lasting as long as a hundred years or more. When a new one needed building, Morse says, "you'd build it like the old one."

Times and technology change, of course, and the advent of oil-fired evaporators and plastic sap lines led many commercial makers to reverse the old calculations. Now the sap is brought down from the sugar bush and close to oil delivery trucks and syrup customers' vehicles. Reverse osmosis (shortened to RO by insiders) is also integral to modern sugar making: Forcing the sap through specialized membranes strips out 75 percent of the water and makes the boil-down that much faster.

The combination of RO and oil is too much for guys like Morse and Stuart Osha, a sugar maker in Randolph, Vermont. Both swear something important in the flavor gets lost that way. Nowadays, they prefer to sleep in their own beds rather than a bare-bones shack, but they and other traditionalists still try to capture that old-time deep-woods essence, making their syrup in small batches over wood fires—though even they put the retail sugarhouses down on the roadside, complete with parking lots.

Osha built a new sugarhouse last year. When pressed to describe its architecture, he says, "Oh, you know, just like ones you see everywhere." And so goes the organic, natural non-evolution of the New England sugarhouse.

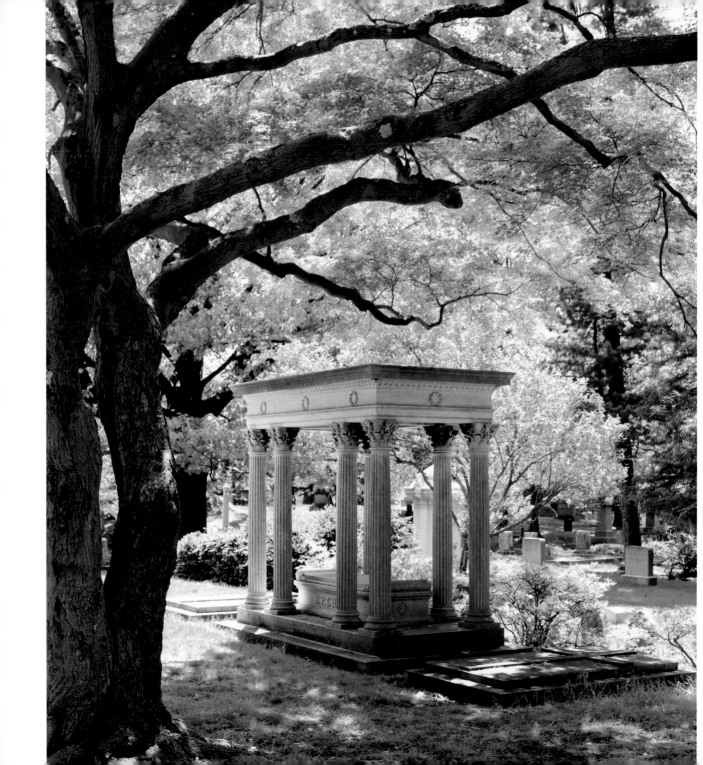

Garden Cemeteries

LONG BEFORE THE FIRST THANKSGIVING, the Pilgrims attended to more pressing business. Only 56 of the original 102 *Mayflower* passengers survived the first winter in the New World, and they buried their dead on a small hill across from Plymouth Rock, without markers and in some secrecy, out of fear that the Natives might become more threatening if they knew how weak the colonists had become. The settlers would soon build a fort on a bigger hill and eventually would use it as a graveyard; Governor William Bradford's ashes are said to lie beneath a large marker there. And in the best New England real estate tradition, first-comers (or is that -goers?) got the best spots: Burial Hill's panorama of Massachusetts Bay is considered by many to be the most magnificent view of any New England cemetery.

In their fierce denunciation of the established church, the early Puritan settlers rejected the idea of churchyard burial as papist and idolatrous, and many new towns set aside land for a community burial spot. Boston's King's Chapel Burying Ground is such a place. The town graveyard had been in use more than thirty years when King James II ordered an Anglican church to be built. No one

would sell land to a non-Puritan church, so the king ordered that a corner of the public graveyard be seized for the purpose.

As the Puritans lost their absolute grip on power, churchyard graves became more common, and if you didn't live close to town or had different ideas about where to spend eternity, you could always establish a family plot out on the edge of your fields. Regardless of their siting, early American graveyards served both as places for the disposal of the dead and as unavoidable and powerful reminders for the living. Latin inscriptions such as *Vive memor loethi* (live mindful of death) and *Hora fugit* (the hour flees) targeted the literate, while winged skulls, crossed bones, and empty hourglasses spoke to everyone. And the message was clear: This earthly life is fleeting, death will come, and the need to prepare for it is urgent. The Puritans may have faded away, but their stern worldview lingered on.

This hair-shirt approach met the future on September 24, 1831, when Cambridge, Massachusetts's Mount Auburn Cemetery was consecrated. Six years earlier, Dr. Jacob Bigelow, a physician, Harvard professor, and botanist, had convened a group of prominent Bostonians to explore the idea of a "rural" cemetery, a place

that would embrace the celebration of lives well lived rather than the fear of ever-present death, the loving God of Unitarianism rather than the punishing deity of the Puritans, and the belief that the beauty of nature would be a balm to those mourning their dead. Even the terminology had changed: Instead of a graveyard, this would be called a cemetery, from the Greek for "sleeping place."

The spot Bigelow and the newly formed Massachusetts Horticultural Society chose was an old farm on the Watertown line, noted for its mature trees and dramatic topography. Its seventy-two acres were also a help, as Boston's five acres of burial land had passed its capacity—in fact, starting in 1811, the city had begun disinterring bodies to make way for future burials. Further planted with thirteen hundred ornamental trees, laid out among the rolling hills, and filled with wandering paths, quiet ponds, and chirping birds, this was no place for crabbed rows of dark slate gravestones and their grim death's-heads. Instead, there was white marble with carved angels, obelisks etched with earthly accomplishments and poetic reflections, and the prospect of taking the omnibus out of the city for a pleasant, inexpensive, and morally edifying stroll with like-

minded people. Mount Auburn was a place for the living as well as the dead, and mourners mingled with tourists, including a sixteen-year-old Emily Dickinson, who wrote to a schoolmate in 1846, "Have you ever been to Mount Auburn? It seems as if Nature had formed the spot with a distinct idea in view of its being a resting place for her children."

The idea proved to be a powerful one, and other such cemeteries opened in quick succession, including Philadelphia's Laurel Hill (1836), Brooklyn's Green-Wood (1838), and, in Massachusetts, Jamaica Plain's Forest Hills (1848). Eventually, the concept reached the West Coast with the opening of Mountain View (1863) in Oakland, California. But the true test of an idea is in its staying power, and by that measure the "garden of the dead" concept has proved to be a giant. Some two hundred thousand people visit Mount Auburn each year, drawn by an ever-evolving version of its founders' original idea. There are now more than five thousand trees, many of them shining and rare examples of their kind and most of them tagged for easy identification. Washington Tower, designed by Dr. Bigelow, sits on the cemetery's highest hill, with sweeping views of Boston awaiting those who climb its granite spiral stair. For its part, Forest Hills straddles the past and the present with enthusiasm and a love of the arts. Not far from the graves of e. e. cummings and Eugene O'Neill are jazz concerts, a sculpture path lined with contemporary works, and poetry readings in Forsyth Chapel.

It seems that we don't mind being reminded of death after all, especially when we can enjoy being alive.

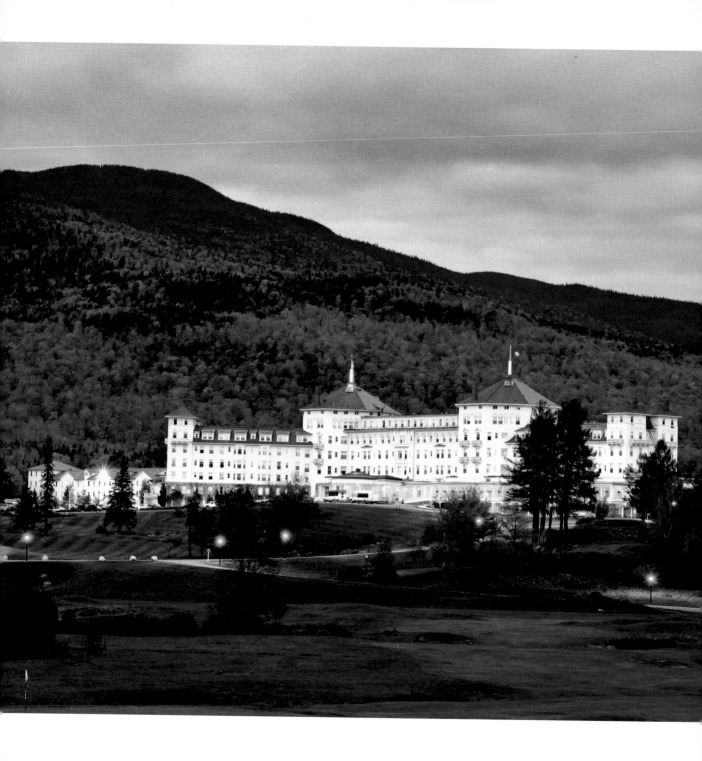

Grand Hotels

IMAGINE THE AMERICAN MIND-SET in the first half of the nineteenth century: The Revolution was well within living memory. Electric power wasn't around, and passenger trains were an exotic sight before the 1840s. People stayed close to their hometowns out of desire as much as necessity. Home was where work and family were, so why leave? Who had the time, anyway? In fact, says Catharina Slaughtterback of the Boston Athenaeum, the word *vacation*, defined as "an extended trip from home," did not gain wide circulation until after 1850.

But gain circulation it surely did, especially in New England. Regional rail and ferry services grew, as did a new thing called the middle class, and a belief that in nature might be found an antidote to the noxiousness—both environmental and moral—of the crowded cities. Slowly, people began to try out the novel idea of actually stopping work, leaving home, going somewhere they'd never been before, and (shocking, this was) staying with people they didn't know.

Never ones to shy from making a dollar, Yankee businessmen were there to work when others chose to stop. One of the first

was Thomas Handyside Perkins, a wealthy Boston Brahmin who in 1823 built the seventy-room Nahant House on the eastern shore of the Nahant peninsula just fourteen miles north of Boston. It catered to some of America's earliest vacationers, those to whom relaxation came more easily: "gentlemen of wealth and leisure, and ladies of taste and refinement," as one historian described them in 1845. The hotel featured bowling, billiards, and the rather newfangled concept of a bathhouse.

The Nahant House was famous for the open-air piazzas that ran around its two main stories. The first-floor level was for men, the second for women, the strict segregation reflecting a societal concern surrounding the rise of leisure pursuits—what one Christian publication called "the Amusement Problem." Was free time spent out in public a good thing, healthful and mind-broadening, or was it an invitation to moral turpitude, idle hands (and bodies) inevitably doing the devil's work? Commentators were split, Slaughtterback reports, but an early consensus had it that amusements "were permissible only if they enabled Americans to work harder and to refrain from yet more sinful activities."

Thus blessed, working-class men and

women were ready to heed their inner vacationer, and by the mid-1800s dozens of resort hotels were open to lodge them. Nantasket Beach, developed in the 1870s, was the South Shore of Boston's answer to the Nahant House and its more exclusive cousins along the North Shore. "Palace hotels" such as the Atlantic House and the Rockland House were served by train and ferry, and the four-mile beach was where, as one guidebook put it, "Anglo-Saxon-Celtic-Latin-Slav Boston sends tens of thousands of her citizens on torrid summer days."

No matter how many hyphens in your demographic, there was a New England hotel sure to suit you. The railroads pushed ever northward, opening up previously unreachable "wilderness" to folks in search of cool, clean air and the promise of diversion—though the trip was surely an adventure in itself. It took the Boston train five and a half hours to get to the Pemigewasset House in Plymouth, New Hampshire, almost triple today's driving time. Farther still was the Mount Kineo House on Maine's Moosehead Lake, where gentlemen could "live in woolen shirts and appear in them at all times, without giving offense or appearing discourteous." As with most of these

hotels, one of Mount Kineo's draws was refreshing breezes, a powerful attraction in a time before air-conditioning.

Many hotels had their own dance bands; dining guests at the Crawford House in Crawford Notch, New Hampshire, were treated to a special number called the "Breakfast Bell Polka." Vermont's Willoughby Lake House featured a fountain stocked with fish from the lake and an area where wild bears were chained to stakes. Such diversions seem positively antique, and they did indeed pass from the scene—as did many of the hotels themselves. Not a single one mentioned so far survives. Many burned, and as consumers demanded more modern amenities, others became white elephants whose fate was the wrecking ball.

Yet some live on. The Mount Washington Hotel opened in 1902, hosted both Babe Ruth (who loved the golf course) *and* the Bretton Woods Monetary Conference, slid into a worn seediness by the 1980s, and then came back to vibrant life after an extensive renovation in the 1990s. The revival was so successful that in 2009 the owners put thirty million dollars more

into a new spa and conference center, topped off with a roof garden.

In New Castle, New Hampshire, Wentworth-by-the-Sea, built in 1874, has a similar riches-to-rags-to-riches story. Closed in 1982, it sat unoccupied for years behind a ten-foot chain-link fence, eventually making the National Trust for Historic Preservation's list of "most endangered properties." The nonprofit Friends of the Wentworth and the state of New Hampshire worked together to stave off demolition with an assist from a new owner, who eventually spent twenty-five million dollars putting it back on its feet. It reopened in 2003 and is now a Marriott property with 161 guest rooms.

Other handsome survivors include The Balsams and Mountain View in, respectively, Dixville Notch and Whitefield, New Hampshire; the Equinox in Manchester, Vermont; the Colony Hotel in Kennebunkport, Maine; and the oldest of all, the Red Lion Inn in Stockbridge, Massachusetts. It's been welcoming travelers since 1773—when the Revolution was in the minds of only a few.

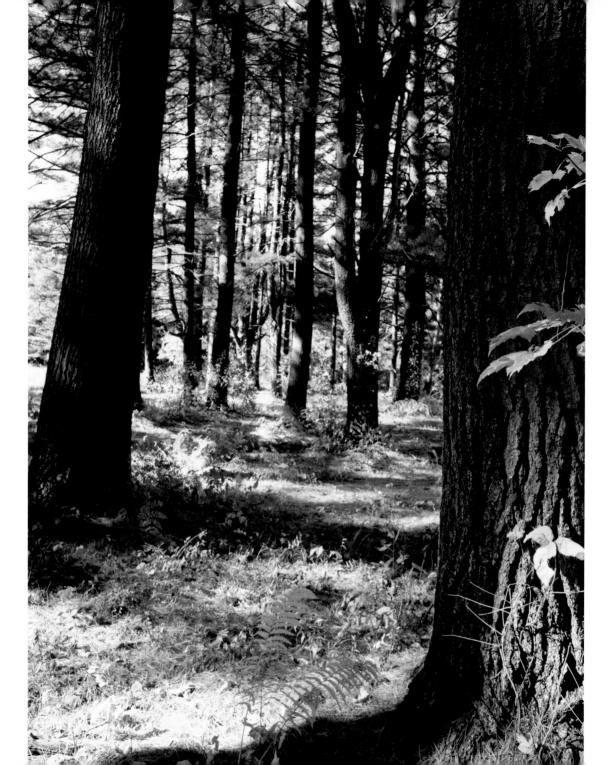

The Forest

THE NEW ENGLAND WOODS are beautiful. They start at the edges of the ocean and just keep going, attracting hikers, strollers, leaf-peepers, maple-syrup lovers, and just about anyone in search of a real or imagined ancestral connection to the land. In them, we feel far from the clamor of the modern world; with not too much effort, we can dream we're in an American Eden.

Henry Longfellow gets the credit for "This is the forest primeval," the catchy opening line for his 1847 blockbuster *Evangeline*. Although the days of blockbuster poems are gone, and although he was talking about Nova Scotia rather than New England, the images conjured by the phrase still inform our perception of what the New World was like "pre-settlement": thick, dark forests of towering trees and impenetrable undergrowth.

Of course we know better than to think that the Europeans "discovered" a virginal America, but it might come as a surprise—as it did to the first colonists—just how visible the hand of man was upon the early New England environment. It seems that the Native Americans had been using fire in the forest for hundreds if not

thousands of years—the result being open, park-like spaces of mature oaks, chestnuts, and white pines. Early observers often reported on the ease of riding a horse or driving a wagon through such forests, and theologian and early colonist Roger Williams wrote of the Native inhabitants, "This burning of the Wood to them they count a Benefit, both for destroying of vermin, and keeping downe the Weeds and thickets."

These forests were found along New England's southern coast and inland rivers where Native populations were the highest, and the advantages were obvious. Using frequent low-intensity fires (usually set in the spring and fall), the Native Americans provided themselves with easier travel, increased visibility of game and enemies, enriched soil for agriculture, and cleared spots for settlement. The scorched forest floor yielded large amounts of "mast and browse," the kind of berries, nuts, young leaves, and shoots beloved by white-tailed deer, bears, moose, grouse, and turkeys—which in turn were beloved by Native hunters.

While the new European arrivals were not known for their hunting prowess (many starved in the first years of settlement), they did know how to build. They needed houses and, soon

after, furniture, and they knew easy pickings when they saw them. Down came huge oaks and chestnuts—some of them three or four centuries old—and up went heavy English timber frames. Pines were the first to fall for furniture, harder-to-work oak a bit later.

Change came quickly to the forest. Smallpox and other European diseases, which had been spreading through the Native American population since earliest contact with Europeans, were in full fury up and down New England. The very people who had shaped these woods were disappearing from the land, their culture displaced by another, with different land-use needs. Cleared for farming and grazing, heavily logged, and "freed" from fire, the forest for the "new Americans" became something to be removed completely or exploited for lumber, but certainly not sculpted in the Native American way.

Nowadays the woods continue to provide products, and a living, to New Englanders. There are crops like maple syrup and Christmas trees, with white pine and red oak the two most commercially favored species for cutting, according to George Frame, chairman of the New England Society of American Foresters. "Good prices are also paid for cherry, sugar

maple, white ash, spruce, fir, yellow birch, paper birch, and other species," he says. Trees are harvested year-round and provide pulp for papermaking, wood chips for electric co-generation, and material for transportation pallets, wood pellets, and firewood. And as in the early days, the woods yield timbers and dimensional lumber for the building industry, and boards and veneers for furniture making.

If left alone to regenerate, however, these woods start to resemble our old idea of the forest primeval—the Harvard Forest in Petersham, Massachusetts, is an excellent, lush, and beautiful example. But if you want a taste of what Myles Standish experienced, forest researcher Brian Hawthorne suggests a visit to the Perkins Farm Conservation Area in Worcester, Massachusetts. In an unlikely confluence of events, local vandals have over the years set fire to the forest, keeping it clear of understory. It has no chestnuts (most of them were lost to blight in the early 1900s) and the oaks are only about a century old, but the woods evoke what the early colonials saw.

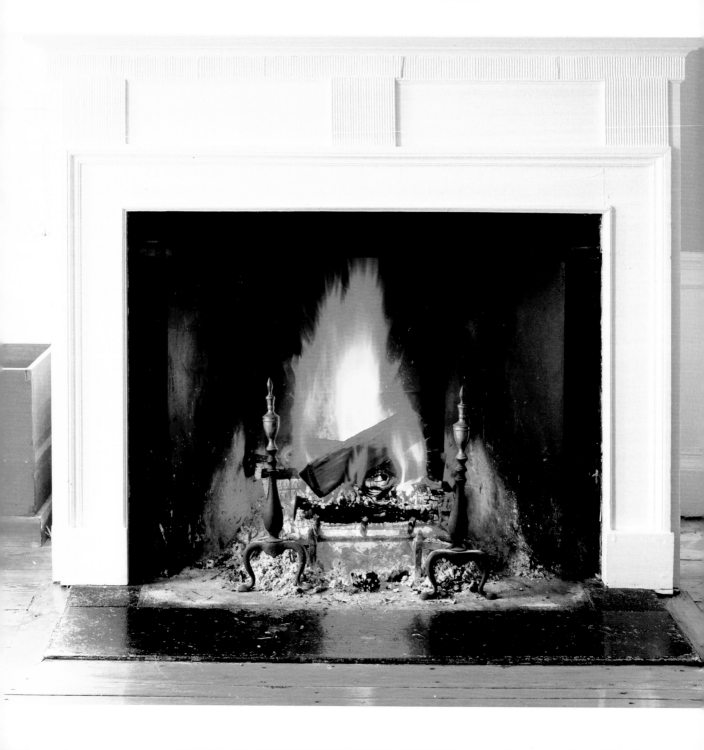

Fireplaces

AH, THE NEW WORLD. For the first settlers, it had more of just about everything (except religious persecution and overcrowded cities). Colonists loved to write home of bird flocks so dense that they blotted out the sun, fish so abundant they could be walked across "dry-shod," and enough land, well, to start a new country. But who knew they'd be so taken by the logs?

The Reverend Francis Higginson, writing from Salem, Massachusetts, in 1629, noted that "in the winter season for two months space the earth is commonly covered with snow, which is accompanied with sharp biting frosts, some more sharp than is in old England, and therefore we are forced to make great fires." Fortunately, he reported, there was plenty of firewood: "Nay, all Europe is not able to afford to make so great fires as New England." He sums up, "Here is good living for those that love good fires."

Every New England house started with a fireplace. Even the earliest dwellings—dugouts cut into embankments or domed wigwams of bent poles modeled on English field shelters—were constructed around a solidly built heat source.

To build them, the materials at hand had to suffice: fieldstones and sticks held together with a mortar made of clay and grass. As time went on, the houses became more substantial and sophisticated, and so did the fireplaces. Salem had the region's first recorded brick kiln in 1629, and demand for its product must have been as huge as the central chimneys the colonists built to service their capacious hearths.

In the kitchens, fireplaces were practically walk-in affairs, as large as ten feet wide, six feet high, and six feet deep. Full of andirons, pokers, tongs, shovels, spits, kettles, cooking cranes, ladles, trivets, frying pans, Dutch ovens, and a built-in baking oven, they served all the family's cooking needs—and some of its social ones as well, as flanking high-backed benches known as settles made for warm gathering spots.

Early flues were so big, Benjamin Franklin later estimated that all but a sixth of the heat went up old chimneys. It took an expatriate from Woburn, Massachusetts, to improve on that. Born in 1753, Benjamin Thompson was a Loyalist who eventually ended up in Bavaria, where he was given the title Count Rumford for contributions as diverse as founding a public park, reorganizing the army, and devising a nutritious soup for the poor. His greatest achievement, however, was designing a fireplace with angled sides and a shallow back to radiate heat and a streamlined throat to increase the draw. Hotter and nonsmoking, Rumford fireplaces were an instant hit on both sides of the Atlantic during the 1790s and are still built today.

But you couldn't cook in a Rumford, so it took the invention of cast-iron cookstoves to hasten the end of the deep kitchen fireplace. They started to make inroads in New England in the early 1800s, though it's debatable as to the improvement they brought to women's lives. "The early stove," wrote the archivist Otto Bettman, "was an appliance of marked obduracy, a penal rockpile on which many a good country wife prematurely spent her beauty and strength." As stoves improved, however, the cooking fireplace became a thing of the past, and by the 1830s, some of the newly introduced Greek Revival homes were being built with stoves instead of fireplaces, their narrow chimneys signaling fashionableness.

Still, so deep-seated was the idea of the hearth that even these homes had mantelpieces, though they surrounded a stovepipe rather than

a fireplace. Later, it was not uncommon to see houses with central heating sporting mantelpieces simply placed on a parlor wall, acting as the focal point where a blazing fire once was. After a while, New Englanders began to long for those blazes of yore—both Ralph Waldo Emerson and Herman Melville wrote of the charms of the fireplace, and people complained about the smell of hot stoves and the unnaturalness of confining dancing flames in iron boxes. The 1876 centennial triggered a wave of nostalgia for colonial America, and by 1900 the fireplace reappeared in new homes, crackling away merrily while the coal-fired furnace in the basement heated the house.

Today the practice continues. Old or new, most New England houses have at least one fireplace, as superannuated as a butter churn but still proudly displayed. Why? "I find that the idea of 'hearth and home' still holds true, quite literally, in the twenty-first century," says Boston interior designer Michael Carter. "Even in a brand-new South End loft, you'll find a fire drawing people together at an instinctual gathering point." Cambridge, Massachusetts–based architect Frank Shirley points to the way that a fireplace appeals to all the senses. "Not only does a fireplace itself give a room a focal point," he says, "but a live fire captivates the eyes, feels wonderful on the skin, and smells great. Light a fire, and you guarantee that family and friends will be drawn around it."

So next time you find yourself in the jaws of a New England winter, gather your family and friends around a fire and raise a glass: "Here's to good living!"

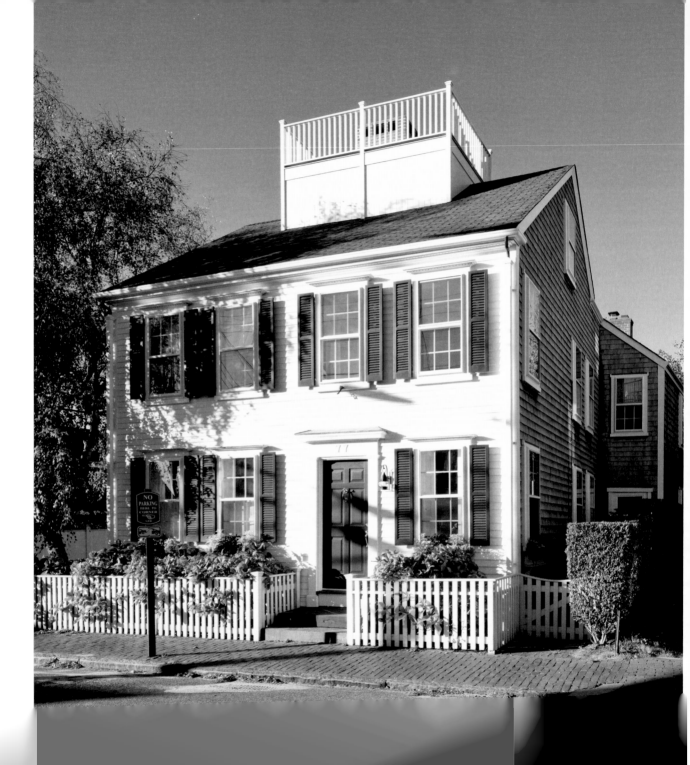

Roof Walks

ONE MIGHT ASSUME, judging by the number of widow's walks capping New England's colonial houses, that black crepe was a hot item in towns like Salem and Nantucket. Then again, one wonders, why would a husband pay good money to build something that predicted his own demise? And what was it called when it was new? A wife's walk?

It's all very puzzling, unless, of course, the name given to these balustraded rooftop decks is fanciful—which it is. The fact that many houses well inland sported such walks indicates there was a less romantic reason for their existence. Look no farther than the hearth: Colonial chimney walls collected grease from the foods being cooked below, which, when combined with the usual creosote and sparks, made chimney fires an ever-present danger. Many houses had holes cut in their roofs, reached by a ladder with a trapdoor at the top and buckets of water or sand stored at its base. In seafaring Nantucket, at least, these holes were called scuttles, just as on a ship's deck. Elizabeth Oldham, of the Nantucket Historical Association, says that "going up-scuttle" was what Nantucket residents did to douse a chimney fire, clambering along the roof ridge

and pouring the water or sand down the flaming flue.

When the good people of Nantucket weren't risking their necks carrying heavy buckets on their roofs, there was that harbor view to appreciate. Historian Edward K. Godfrey, in his 1882 book *The Island of Nantucket*, described the evolution of the roof walk: "In the earlier days, ships were constantly arriving and departing, and of course everybody was interested in the sight; consequently the highest point of observation was sought, which was necessarily at the top of the house. Many well-to-do people, finding the accommodation of the [scuttle] very limited even for one person, added these walks to their houses, thus giving ample room for the whole household to walk back and forth on the top of the house and see all there was to be seen." Chris Dallmus, an architect with extensive experience on Nantucket, points out that roof walks were also useful in fighting fires that resulted from embers landing on wood-shingle roofs, a common occurrence in the densely packed downtowns. Straddling the roof ridge, the walks were rectangular or square in outline, and their balustrades complemented a house's architecture.

The first use of the phrase *widow's walk* is hard to determine, but an article in the *Boston Transcript* from the 1920s said it was "a city term" not used by islanders, and the president of the island's historical association protested in 1925 that "as all good Nantucketers know, they are just plain 'walks,' and were never called anything else until quite recently." He appealed to members to "make a point of correcting anyone who called them otherwise."

Unless you know someone whose house has one, the roof-walk experience is hard to come by. Most museum houses shudder at the idea of letting visitors roam around a platform surrounded by historic-height balusters (read *low*, read *dangerous*). Fortunately, there is one place that allows for going up-scuttle, located, fittingly enough, on Nantucket. The Nantucket Whaling Museum boasts a forty-six-foot-long sperm whale skeleton, an intact 1847 spermaceti-candle factory, and a rooftop walk that, while not exactly vintage, gives a wonderfully briny-air view across the town and harbor.

And if you want one of your own, architect Frank Shirley thinks you should have one. "They're a secret hideaway," he says. "They're private, but they've got to be done right." He follows a few simple rules: If the house ridge

parallels the street, shift the majority of the walk behind the ridge so the walk's apron isn't too tall; try to keep the walk to no more than a third of the main ridge; and, if your house already has railings and trim, replicate them on the walk. And avoid the desire to supersize. Architect Dallmus reports a trend to bulk up modern Nantucket walks. "I hear there's one with a hot tub over on Cliff Road," he says.

Hey! That could come in handy in a fire.

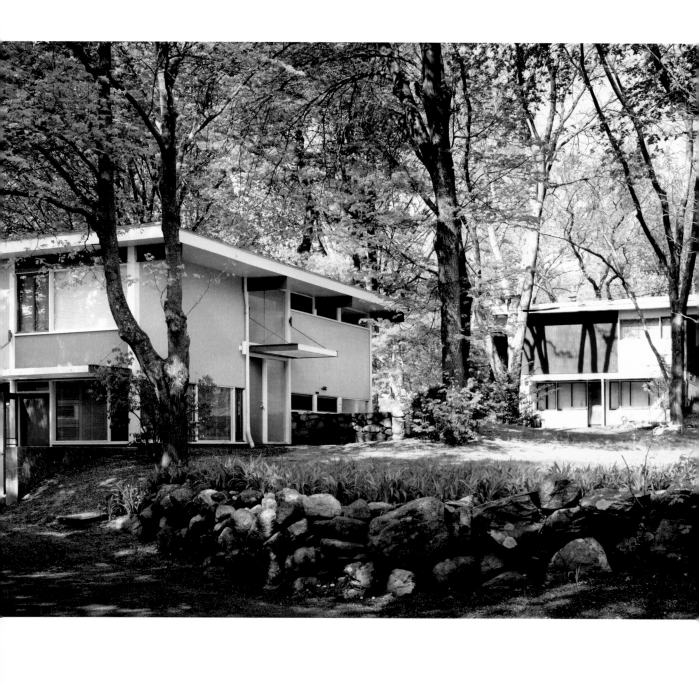

Modernist Communities

DEEP IN THE ROCK-RIBBED Yankee heartland of eastern Massachusetts sit little pockets of—gasp!—socialism (and we're not talking about Cambridge). Planned communities with a deeper founding mission than, say, Long Island's Levittown, these are New England neighborhoods with DNA tracing back not to Anglo-Saxon lands, but to Germany. Startling when they were first built, they live on today—and in good health—though much of the region seems to have caught up with many of their once-radical principles.

While modernism yielded some early individual buildings in the region, the full flowering of the style and its communal ambitions didn't occur until architect Walter Gropius fled Nazi Germany and landed at the Harvard University Graduate School of Design in 1937, bringing with him the socialist ideals of the Bauhaus movement. He also brought the need for a house of his own in his new homeland. The Gropius House in Lincoln, Massachusetts, is now a revered icon visited by thousands each year, but when it was built, it was also part of a unique enclave. Between 1938 and 1939, Gropius and Harvard colleagues Marcel Breuer and Walter Bogner

created their own little neighborhood on twenty acres provided by the philanthropist Helen Osborne Storrow. Known today as the Woods End Road Historical District, it is the earliest collection of International Style houses in the country.

At a time when postwar Americans were trying to return to some kind of group "normalcy," and in a region where the traditional held sway, Gropius was saying things like, "The key for a successful rebuilding of our environment will be the architect's determination to let the human element be the dominant factor." No doubt there were some receptive ears, but it took the true believers to put Bauhaus egalitarianism into practice.

In 1945, Gropius joined with a group of his former students to create The Architects Collaborative (TAC), a firm devoted to modernist architecture. In 1948, driven certainly by their beliefs but perhaps also by necessity (three couples who worked at TAC shared a humble triple-decker in Cambridge), firm members purchased twenty acres of rocky hillside in Lexington and set out to replicate Woods End Road for themselves. Six Moon Hill was so named because the seller had left six antique Moon cars in a barn on the property. The

young architects drew straws for their lots, designed and built small homes, and formed a cooperative with shared governance and communal space, such as a pool and recreation area. It was experimental, as was the mass-produced Levittown being built at the same time, but compared with that overtly economic model, it was almost artistic in its civic-mindedness. In *Still Standing*, a 2006 documentary about TAC, Norman Fletcher, a firm founder who died in 2007, recalled, "[We] had an idea that somehow we were smart enough to create ideal communities and by doing so create a peaceful world."

Pure economics played a bigger part in the Six Moon Hill gang's next project. Emboldened by the success of their own neighborhood—and eager for more commissions—TAC members purchased an eighty-acre Lexington farm, named the community-to-be for its five fields, and in 1951 began selling lots with houses of several affordable ($19,950 to $36,000) stock designs. It, too, had communal land, a pool, a playground—and an atmosphere that attracted people unlike the standard Lexingtonians of the time. As described in a fifty-year anniversary publication about Five Fields, the town's population was "rather homoge-

neous and conservative, almost entirely Republican." Put off by the architecture, some townspeople called the development "Chicken Coop Hill." Most buyers came from out of town, out of state, or overseas. Attracted by its progressive promise, its new residents "practiced a variety of religions or no religion at all with some mixed marriages and greater than expectable number of adopted children," the retrospective reports. "They included an African-American family. They tended to be politically liberal and predominantly voted Democratic." Sales were brisk.

Seeing that it was possible to do well by doing good, others soon joined the game. W. Rupert McLaurin, a Massachusetts Institute of Technology economics professor with a vision of affordable housing for young couples, joined with MIT architecture professor (and Gropius student) Carl Koch to build Conantum, a 190-acre, hundred-home development near the Sudbury River in Concord. Prices began at ten thousand dollars, and at a time when such things were uncommon, the houses came with an anti-discrimination clause in their deeds.

Today these and other modernist neighborhoods around Boston continue to thrive. Peacock Farm and Turning Mill in Lexington and Snake Hill in Belmont all retain their minimalist, trapezoidal houses, and while most have been expanded, the additions are in keeping with the original style. Indeed, several of the neighborhoods maintain strict control over exterior changes, but that didn't bother Jennifer Goldfinger, who recently moved her family into a 1958 Peacock Farm house designed by architect Walter Pierce. "The natural light pouring through the windows is just wonderful," she says. "We feel like we're in a tree house, with a powerful connection with nature, with birds, and the weather." She attended her first neighborhood association meeting soon after moving in. "You have to ask permission to do just about anything to your house, including changing its color, but that doesn't bother me. The people at the meeting—and it was packed—were great. I've only been here a short time but I can tell I'm surrounded by very interesting, intelligent neighbors." Somewhere, Walter Gropius is smiling.

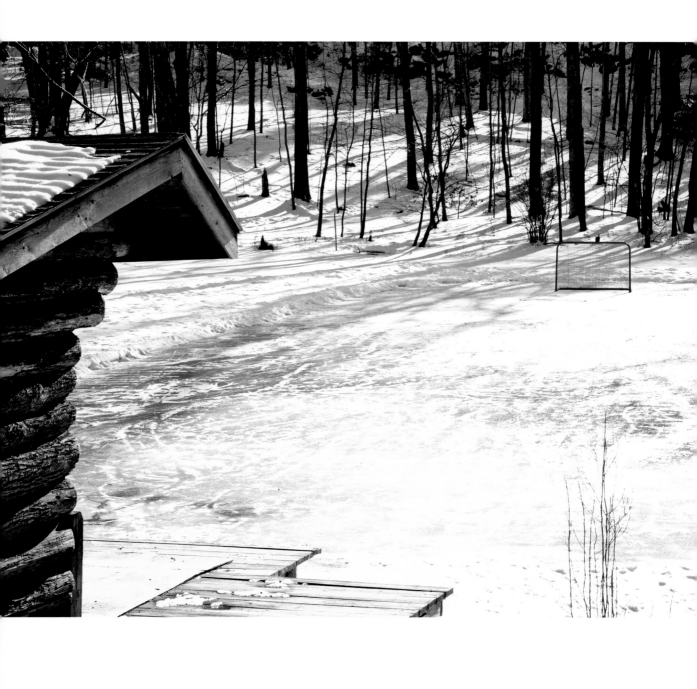

Skating Ponds

WHEN THE GREAT ICE AGE glaciers retreated about thirteen thousand years ago, they left little watery reminders of themselves all over New England. The region's lakes and ponds are so numerous—three thousand in Massachusetts alone—that just about everyone who grew up in the region has a tale to tell about skating on one. Without the neighborhood pond and its merry skaters, Currier and Ives would have had a much tougher time rounding out their catalog.

While there seems to be some argument about who introduced hockey to North America (the Micmac Indians of Nova Scotia or British military officers), it's almost certain that Europeans brought the skate here and with it the idea of sliding around on the ice for pleasure. The colonists strapped on wooden platforms with metal blades—often imported from Holland, Germany, and especially England—though New Jersey's first governor, William Livingston (1723–1790), recalled that the skates of his boyhood were made from beef bones. This isn't as far-fetched as it might sound: The oldest known pair of skates, dating to 3000 BC, were made from the leg bones of a large mammal. They were found at the bottom of a

Swiss lake, proving that even ancient mothers had good reason to worry about thin ice.

The danger persisted in the New World. Samuel Sewall, who went on to be one of the Salem witch-trial judges, recorded in his diary on November 30, 1696, that "Many scholars go to scate [sic] on Fresh-pond" in Cambridge, Massachusetts, and that two Harvard students fell in and drowned. And on January 8, 1728, teenage brothers George and Nathan Howell drowned, "skating at the bottom of the [Boston] Common, the ice breaking under them."

Regardless of the danger, the lure of frozen ponds seems to have trumped their menace, and when in the 1850s *The Atlantic Monthly* magazine published Colonel Thomas Wentworth Higginson's article "Saints, and Their Bodies," it was made clear to readers that rigorous outdoor exercise was good not only for the body, but also for the Christian soul. Among the colonel's exhortations toward "manly vigor" was to skate, and he described it in glorious Victorian prose: "Skating, while the orange sky of sunset dies away over the delicate tracery of gray branches, and the throbbing feet pause in their tingling motion, and the frosty air is filled with the shrill sound of distant steel, the resounding of the ice, and the echoes up the hillsides . . ."

Thus inspired, thousands of Bostonians would head to nearby Jamaica Pond on special excursion trains of the Metropolitan Horse Railroad Company (with signs on the cars advertising "Good Skating"). When it snowed, the company paid for the pond to be cleared.

The public and private use of ponds has long been part of the winter equation, Weston, Massachusetts, being a good example. There were two well-known ponds in town, one for an upper-class crowd and one for the working class. The pond on the Robert Winsor estate was popular with ladies and gentlemen who were attracted by the curling, figure skating, and hockey areas, but even more so by Mrs. Winsor's hot coffee, tea, and marshmallow-dotted hot chocolate, which she herself ladled out in the pond-side warming hut. Unfortunately, her generosity attracted an influx of strangers "from outside the community," causing the pond to be shut down. Today it's open again (though private), and the original hut still stands. Across town, Foote's Pond was frequented by working folks, some of whom also cut ice there, each harvest resulting in smooth new ice to skate upon. Nowadays, the issue is less about class and more about climate. Weston bought College Pond in the 1970s.

Open to all, it has suffered recently from warm winters, so the recreation department built two shallow rinks, which freeze faster and more reliably, behind the town's community center.

Beating back matters of both class and climate is that most beloved and unnatural of watering holes, Boston Common's Frog Pond. For more than two hundred years, it was fed by runoff from nearby Flagstaff Hill. In 1848, it became part of the city's waterworks system, and in 1997 the now concrete-lined pond, less than a foot deep, was given a subsurface refrigeration system. It's been open for at least a hundred days of skating a year ever since. At four dollars a person, with children under thirteen free, it gives every modern New Englander, and visitor, a chance to join a long tradition—without falling in.

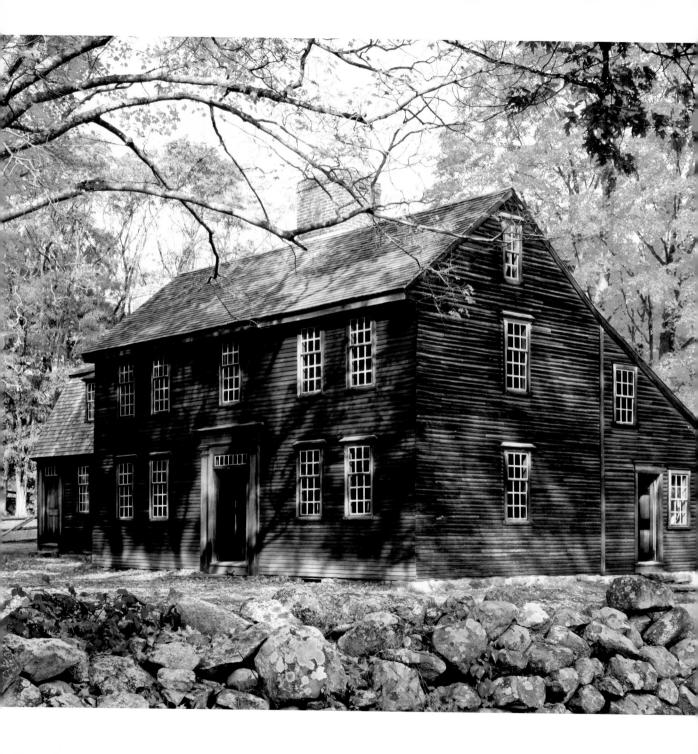

Saltbox Houses

CAPES CONTEND, but for "house that says New England," the winner has to be the saltbox: hunkered-down survivors, sloped backs to the north wind, redolent of wood smoke and traditional colonial American values. And indeed, this type of house is specific to New England, where the transition from "what we had in England" to "what we need over here" took place not too long after the first American houses went up.

It goes something like this: Early colonists brought with them from England their model of solid middle-class housing—a timber-framed structure with two rooms on the first floor and two on the second, with a massive central chimney running up between each pair. One downstairs room was called the parlor and contained the better furniture and the best bed, for the parents; the other downstairs room was the hall, a combination living room and kitchen. Upstairs were sleeping chambers and storage. Sooner or later, however, most colonists faced a dilemma known well to today's suburbanites. With rising fortunes and growing families (often a dozen or so people would be crowded into these early homes) came the desire for more living space.

Which way to expand? Most of the cooking was done in the hall fireplace, smack in the middle of things. With all that activity, it's easy to see that extending the working parts of the new American home took precedence over expanding the upstairs. It can be argued that saltbox expansions were the simplest option. The house's side walls were extended, a flat roof was attached to the main roof, and a back wall finished things off—four easy planes, no complex framing, no gabling, no new ridgelines, done in time to continue the planting. The addition seemed to simply lean against the older structure, and indeed saltboxes were often called "lean-tos," especially in Massachusetts.

Still, there was some subtlety involved. Simply continuing the rear roofline of a house with low eaves would not yield enough ceiling height in a rear addition; similarly, a steep roof pitch, if extended, would result in an addition not deep enough to merit the trouble. Thus it became common practice to change the roofline where the shed met the main house so that the rear rooms would have decent depth and ceiling heights. This two-pitch profile is how saltboxes earned the (primarily Connecticut) nickname "break-

backs." The resulting massing was strong, simple, and very much like the once-common salt container.

Into the new space went a fairly regimented trio of rooms: a large kitchen (sometimes called a "keeping room") in the center; a small bedroom on one end; and a buttery or dairy, usually located at the coolest, northernmost end, and sometimes dug into the ground to keep things even cooler. The bedroom has had the name "borning room" attributed to it, though with a dozen people in the house, it most certainly was used by others besides delivering mothers—often grandmother or grandfather, since it was nice and warm next to the kitchen, with no stairs to climb. The kitchen demanded a fireplace, of course, and so onto the central chimney was grafted a new rear flue. And there was usually a steep secondary stairway leading to a low-ceilinged attic.

Every prosperous household seemed to want a lean-to addition. The house that John Adams was born in was a saltbox; he evidently liked the arrangement enough to move into another one, just seventy-five feet away, where his son John Quincy Adams was born. The whole package was such a success that the lean-to began to be built as an integral part of new

houses. One of the earliest examples is the Whipple-Matthews house, circa 1680, in Hamilton, Massachusetts. It's still a private home, reports Butch Crosbie of the town's historical society. "We have several other saltboxes in town that are also private, which proves what a successful form it is."

Winning though the arrangement was, however, it could not withstand the greatest of all American forces: fashion. After the mid-1700s arrival of the Georgian style, the saltbox began to fall out of favor. Nowadays, few are built, and only by homeowners with a strict historical-replica agenda. "We do rear expansions differently now," says Boston-based architect Jeremiah Eck, "since stick framing allows for quick full-height additions to be put on, thus avoiding the nasty low-ceilinged lofts of saltboxes. And with our better insulation and heating systems, we no longer have to turn a low slope to the cold north winds."

But the arrangement of domestic spaces the old saltboxes introduced—kitchen, pantry, and a bit of extra space, all at the rear of the house—lives on. Just ask any architect or builder.

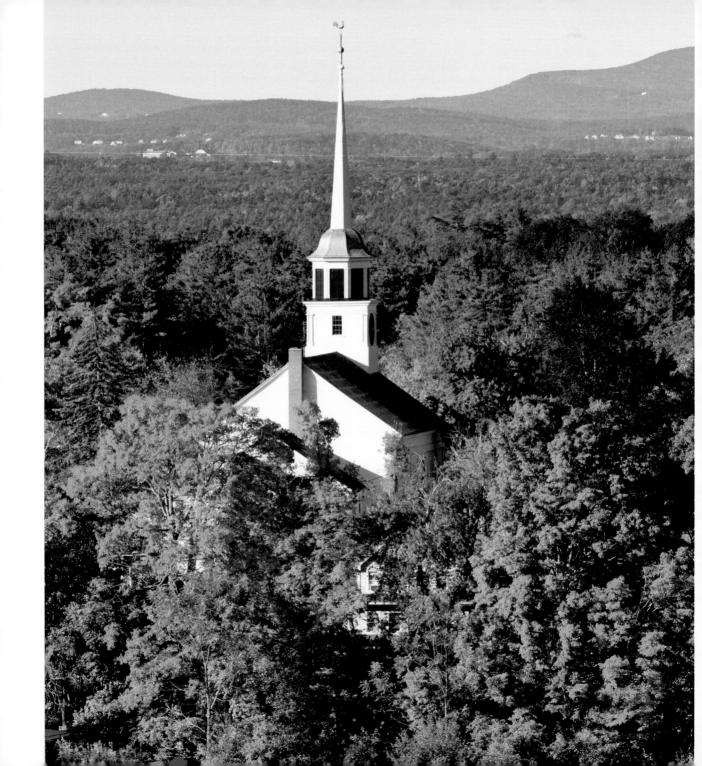

Church Steeples

 A PICTURE POSTCARD of a quintessential New England town today would surely include a white clapboard church under a distinctive pointed steeple. Churches and steeples—they're part of our earliest colonial roots, right? It turns out the first New England churches didn't have steeples at all. They weren't part of the religious vocabulary, nor were they a viable project initially: In an environment where one out of two Pilgrims and one out of seven Puritans didn't survive their first winter, there were more pressing needs than erecting a tall and complex structure housing no one.

Their first houses of worship were a continuation of the practice of meeting communally—and often in secret—in private homes. Free at last in the New World, colonists built their meetinghouses with entrances on the long side facing the road and a pulpit facing the door. There were no altars, no carved decoration, and the structures were small, usually less than a thousand square feet, of humble wood rather than stone.

The embellishments began soon enough: In 1640, the New Haven meetinghouse had a turret, the first on record, which

held a bell for calling the faithful to services. Slowly but surely, with each meetinghouse expansion or new village church, the skilled joiners of New England climbed ever higher to build the steeples that came to define the landscape.

In 1806, when architect Asher Benjamin published *The American Builder's Companion*, it contained several plans for wooden churches—with steeples. Benjamin drew on European and American strains of classicism, and the so-called pattern book was widely disseminated and hugely influential. Many a New England town contains a church whose look derives wholly or in part from it.

The steeple form was a tower box first, then a belfry, then a dome, but most often a spire, which sometimes contained a windowed "lantern." Framed in white pine, white oak, or spruce, these structures were not mere elements stacked on top of one another. According to Arron Sturgis, a Maine timber-framer whose firm has restored more than twenty of them, they are telescopic, with framing members interpenetrating those below to handle the stresses of wind and exposure and all connected to the building frame below. Four posts send the load to the

ground, either directly or transferred across roof trusses.

And what a load it is. When Sturgis and crew repaired the Topsfield (Massachusetts) Congregational Church, the crane that brought the steeple to the ground recorded a fourteen-thousand-pound belfry, a seven-thousand-pound spire, and a Paul Revere bell of eighteen hundred pounds.

According to Sturgis, New England's steeples are in the thick of a major maintenance cycle. Their protective skins of clapboard, shingles, and metal face severe weather conditions and wear out way up high, where damage may go undetected until extensive. Worse, many repairs have done more harm than good, especially those done between 1920 and the 1980s. That's when metal brackets and structural pieces were used; they lack the flexibility of the surrounding wood and cause joints to open up and timbers to crack, accelerating rot. "Steeples are dynamic structures designed to move," says Sturgis. "When you pin them tight, they degrade quickly."

Traditional wood joinery methods must be used to restore the steeples, and such work doesn't come cheap. For a steeple with serious problems, the bill can be five hundred thousand

dollars and up. Because getting to the work is so difficult, even less extensive projects like re-siding or painting can quickly get to six figures. Often entire steeples are craned to the ground for repair.

As was true in their early history, steeples today continue to adapt to the times. Some churches have found a revenue source from renting out steeple space for communications equipment. Parishioner Marshall McStay of the Wellesley (Massachusetts) Congregational Church recalls the early 1990s as "the Wild West," with cellular companies offering all sorts of deals for a spot up high. AT&T even replaced the Wellesley spire's copper finial—

which interfered with the signal—with a fiber-glass replica containing a transmitter. Nowa-days, the church has three T-Mobile antennae behind fiberglass panels that replicate parts of the steeple's wood sheathing. Rent is about $2,200 a month, which the church uses for community outreach.

But as many congregations shrink and maintenance expenses rise, perhaps the strongest hope for New England's spires lies in a trend that Arron Sturgis has observed: "These days, towns are seeing churches less as religious buildings and more as community centers and landmarks worth preserving." Amen to that.

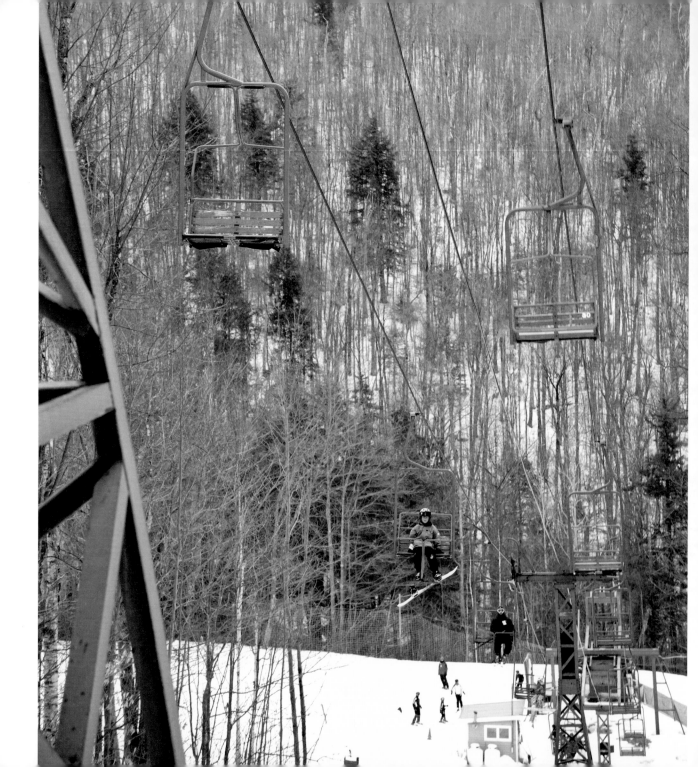

Classic Ski Areas

SOME SKI, SOME DON'T. These days, there are a lot more of us in the former group than there were back in the early 1900s. Back then, New Englanders thought of winter as something to be endured, a necessary evil between harvesting and planting seasons. The only people who would go out in the cold with smiles on their faces were either children or crazies.

But slowly, the crazies began to make a case for the joys of sliding down snowy hillsides (though they never made much headway on selling the climb up). Since the late 1800s, a few hearty Norwegians had been skiing over impassable winter roads around Stowe, Vermont, to the amusement of the shut-in towns-people. Then, in 1921, the newly formed Stowe Civic Club put on its first Winter Carnival. As one attendee was quoted at the time, "Everyone was very excited about the games and races, but the ski jumping seemed to have impressed them the most, and all wanted skis right away." The pro-skiing momentum continued with the 1932 Lake Placid Winter Olympics. Attended by eighty thousand and broadcast to millions via radio, the event, as *Sports Illustrated* put it, made "the entire country aware for the first time

that there was something to do in winter besides wait for spring."

Early New England skiing was a rustic and rugged affair. Only dark and winding secondary roads led to the North Country, inns were rare, equipment primitive. With early skiers piling on layers of wool, strapping on strips of seal fur to provide traction for trudging uphill, and breaking limbs with alarming regularity, it is little wonder that in 1966 *Ski* magazine was still describing the sport as the "frolic of a few freaks."

For solidarity, ski pioneers formed clubs. In Boston, there were (and still are) the Altebirge club, the Ski Club Hochgebirge, the Schussverein club, and the Drifters, all started by Harvard grads. Octogenarian Hochgebirge member David Arnold, still a skier, recalls driving north with skis strapped to the running boards of his car. "Chances were," he says, "if you saw another car with skis on it, you'd know everyone inside." On the mountain, ten or fifteen skiers would be a crowd.

Of course, the mountains were nothing like the resorts of today. Trails were chopped out by hand and many "mountains" were really just hillsides, their proximity to roads and scalability by foot being critical attributes.

Local families looking for winter income, ski devotees with access to land, and colleges with budding ski teams were the usual forces behind these spots.

Jeremy Davis, a meteorologist and avowed "closed ski area enthusiast," runs the online New England Lost Ski Areas Project, which has documented nearly six hundred lost ski areas (the website, Nelsap.org, is a repository of memories, photographs, and mementos). "At one point, we estimate that two-thirds of the towns in Vermont and New Hampshire had a ski slope," Davis says.

There were at least sixty-four in eastern Massachusetts, from Big Red in West Newbury to Cat Rock in Weston to Heavenly Hill in Quincy ("Just 12 minutes from Boston!" boasted the brochure). A for-friends operation in Southborough was called the "Private Property No Trespassing Keep Out Ski Area," so christened by the owner after the Commonwealth sent out a lift inspector from the Recreational Tramway Board (yes, there is one). These small slopes were where many children learned to ski in the 1950s and 1960s. Dunstable's Blanchard Hill (closed 1984) used to charge kids five cents for an all-day lift ticket.

Nowadays, New England has around

eighty-five ski areas. Davis estimates that in the golden year of 1969, Vermont alone had more than two hundred. What happened? "Everything went wrong in the '70s," he says. "Insurance rates shot up, the Vietnam War took away some of the workforce, there were gas lines, and the rising divorce rate did a number on the nuclear family, which had become so important to these areas." Happily, some spots are reopening. Pinnacle Mountain in Roxbury, New Hampshire, shut in 1977, but two brothers who grew up skiing there bought it in 1999 and reopened it as Granite Gorge in 2003. They've recaptured the magic, if a comment they received from one happy skier is any indication: "I like your place way better than the monster mountains. No lines, no waiting . . . no crap!"

Some vintage areas never closed. The most famous is Mad River Glen in Waitsfield, Ver-mont. With its restored sixty-year-old single-chair lift, extremely limited snowmaking, and die-hard clientele (to whom the area has been sold, in shares priced at $1,750 each), Mad River continues to offer up an old-timey New England ski experience—though at $65 a day for adults on the weekends, the similarities only go so far.

For a real taste of the past, there's the Mount Greylock Ski Club in South Williams-town, Massachusetts. It's been operating since 1937, has two (very fast) rope tows, seventeen trails, no snowmaking, no electricity, two out-houses, and one wood-heated base lodge where skiers eat brown-bag lunches. Members take turns running the gas-powered tows and pitch in on fall work weekends. But with family memberships at $150 for the season, you'd have to be crazy not to hit the slopes with a smile on your face.

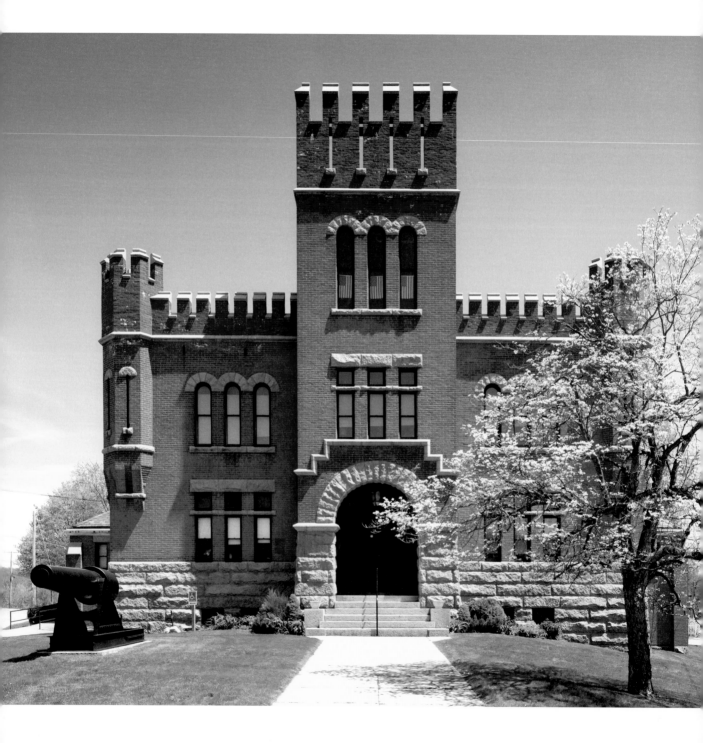

Armories

THEY TAUGHT US IN SCHOOL that the whole idea behind the American Revolution was to get away from kings and all their trappings—pomp, circumstance, sceptres, castles. So why do so many New England cities and towns—home to familiar building types such as triple-deckers, simple apartment blocks, classic Cape Cod houses, and plain white steepled churches—host elaborate piles that look like they came out of the legend of King Arthur? And what are armories for, anyway?

Their beginnings were humble enough. In 1777, the rebellious young country's first armory was established in Springfield, Massachusetts, in a rented barn. The site was chosen for its proximity to the Connecticut River—which could be navigated by small commercial vessels but not by something big (like a British man-of-war)—and because it was at the crossing of two stagecoach routes, which provided good communication with seaboard towns yet was far enough inland to avoid an attack. Used for military storage by the colonists, it later took up musket manufacturing in a new purpose-built structure under orders from General George Washington. (Arms making continued long after the Revolution. The armory

built the famous Springfield rifle that was standard issue for the U.S. military during World War I. The M1 used during World War II was designed and made there as well.) Decommissioned now, the Springfield armory's complex of mostly Greek Revival buildings is the centerpiece of a National Historic Site.

The new republic's Constitution tried, in its blurry grammar, to make it clear: "A well regulated militia, being necessary to the security of a free state, the right of the people to keep and bear arms, shall not be infringed." To support their militias, states built armories, usually modest in size and in whatever architectural styles were current at the time. But after the Civil War, architects embraced the practice of functionalism, based on the idea that the appearance of a building should announce its use as clearly as possible. Churches and banks and houses needed to look different. Architectural style would henceforth carry *meaning.*

An armory, in the words of urban historian Robert Fogelson, needed to look like it housed "a military organization . . . to stand as a symbol of authority, of the overwhelming power of the state, of its determination to maintain order and, if need be, its readiness to use force." What better archetype than a castle? Models

were at hand in the popular Gothic Revival and Romanesque styles, which looked back at medieval fortresses for features like crenellations (notched walls along a battlement, for shooting arrows and other projectiles), machiolations (holes between supporting brackets or corbels, allowing one to drop stones, burning oil, and so forth on attackers), and bartizans (wall-mounted turrets, for sentries).

As outlandish as some of these things sound today, they fit in rather well with the some of the new buildings going up in New England's cities in the late nineteenth century. H. H. Richardson's 1873 Trinity Church in Boston was a gutsy collection of Romanesque details, with great arches, rusticated stone, and substantial pillars. Not far away, on Park Square, William G. Preston designed in a similar style what Fogelson calls the most imposing armory in New England, the First Corps of Cadets building of 1891. Still standing, it currently is home to the Smith & Wollensky steak house and a huge exhibition hall. The building features everything a castle-style (or castellated) armory should. In the front (where the restaurant now is) is a formal administration building: four stories of quarry-faced granite topped off with a corbelled arcade and crenellated cornice, with a hexagonal tower sporting a carved

winged dragon and a battlemented parapet. An interior of rich woodwork, grand fireplaces, and striking staircases (much of it restored by the restaurant's owners) made for a men's-club atmosphere, which was indeed how members of the regiment treated it. Behind, the exhibition space was once a hall for military drills. It, too, bore all the martial marks: entrances protected by heavy iron doors, loopholes for rifles to poke through, windows protected by retractable bulletproof steel shutters, even a "moat" between the sidewalk and building.

Who were these structures guarding against? Was the country in imminent danger of attack from Canada or the Canary Islands? Were the British coming back? A clue can be found in the strong uptick in armory construction following the railroad strike and accompanying labor riots that swept the country in 1877. In response, according to labor historian Philip Dray, the National Guard expanded and armories were put up in cities and large towns to "keep the workingmen in check." The elite was protecting its interests from the mob: Railroads, coal companies, and wealthy individuals all contributed funds for their construction. In Boston, the *Daily Advertiser* newspaper urged citizens to support their armories and militiamen, calling them "the last resort in disturbances of the peace, and in the protection of life and property." Accordingly, the Park Square armory even had its own water supply, using rainwater, should an attacking mob try to cut its service from city mains.

Time passed, the labor movement coalesced around organized unions, world wars came and went, and the armories, with their intimidation factor and bulk, faded in both appeal and economic sense. Some have been lost. Boston's Irvington Street Armory was torn down in the early 1960s to make way for the Mass Pike; Boston University razed the Commonwealth Armory in 2002 and built dorms. Others, like the one in Somerville, Massachusetts, have found new lives. It sat mostly vacant for thirty years, until Joseph and Nabil Sater, owners of Cambridge's Middle East music club, bought it in 2004. Completely restored, it's now Arts at the Armory, a venue for just about every kind of community art event. The Milk Street Armory, built in 1895 in the Old Port section of Portland, Maine, became the ninety-five-room Portland Regency Hotel and Spa in 1984.

Thick steaks, on-stage pageantry, a soft bed at the end of the day—we may have done away with kings, but we'll definitely keep the castles.

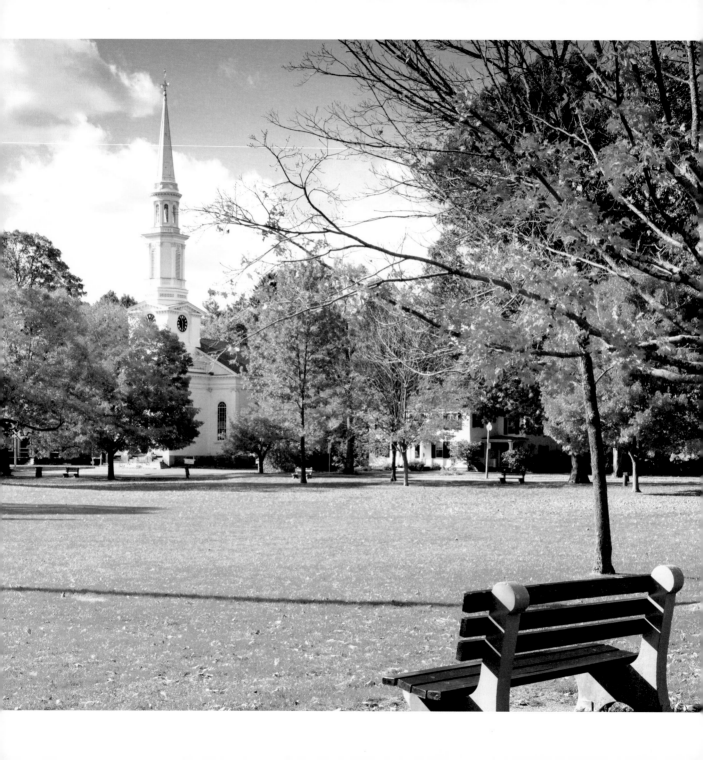

Village Greens

CLOSE YOUR EYES and think *New England village*. There's
a white church. A general store. Maybe a crusty guy named
Eb wearing plaid wool sitting near the cracker barrel. And
out front, always, a green. Clichés, yes, but—with the possible excep-
tion of Eb—based on some reality. Some three hundred New Eng-
land towns and cities have a grassy area called "the common" or "the
green," and it's hard not to see them as central both to these com-
munities and to the very founding ideals of this country. As landscape
scholar and Harvard professor John Stilgoe has written, "Clearly the
space has cultural significance. It is more than a simple public park."

And it turns out to be more than a simple story. In the popular
imagination, the manicured village green got its start as rough-and-
ready common land, set aside for grazing, firewood gathering, and
the occasional hanging. And in early Puritan settlements, that was
true. The Puritans hoped that this new country would cradle their
ideal of community-based religion, and they set up their towns
accordingly, with a meetinghouse (they avoided the word *church* as
an unnecessary distinction between town and religion), prescribed
worship, and a communal compact of behavior and belief. You played

by the rules or you were cast out to godless wastelands like Rhode Island, and, at least in the beginning, you helped plant and tend the communal field and kept your animals in a safe, central common pasture, or "close."

But these were land-hungry people, and the abundant land all around strained the bonds that held them close to the meetinghouse. These were our nation's ur-capitalists; they wanted their own land to farm. Fortunately, they adapted the town system to allow for dispersed landownership while maintaining social and religious ties to a central spot, the village. By the end of the 1600s, most of New England's new communities were collections of farmsteads whose "center" was, at most, a meetinghouse, a tavern, and a store. Much of the common land went into private ownership, but in the center a portion survived as "the lot," which held the meetinghouse and a small amount of land. Worshippers coming in from the surrounding countryside tethered their horses there, and militias trained. Town militias occasionally converged on the most famous former pasture of all, Boston Common, which hosted large exercises from early on.

The church chokehold on the New England body politic began to slip by the late 1700s,

and the meetinghouse became a much more secular place. Commerce grew as farmers could afford goods and services provided by others. Since many roads converged on town greens, tradesmen began to open shops there, markets developed, and the tavern became the place to congregate after Congregational church service.

Blacksmiths, harness makers, shopkeepers, bankers, and lawyers all wanted a piece of the action in the town's center. For the most part, communities kept the greens themselves out of private hands and used them for public assemblies, agricultural fairs, and—as the republic aged and nostalgia set in—memorials to the War of Independence, with Lexington, Massachusetts, establishing its stone monument in 1797.

In time, subsequent wars would be memorialized, bandstands would be built, and a desire would grow to groom these formerly hardworking places. Citizens pulled stumps, removed rubbish, spread grass seed, and planted trees. In the late nineteenth century, the green at the heart of a town began to be seen as a symbol for simpler times. Its appearance said a lot about a community, and some wealthy citizens took to funding their village green's improvement and upkeep. There were setbacks: The rise of the automobile turned

some greens into traffic islands ringed with road signs. And when the hurricane of 1938 struck, thousands of trees on hundreds of greens fell. It took decades for many of them to recover their shade. The bicentennial did much to revive interest in greens. Cambridge staged a major overhaul of its common to prepare for the festivities, and many other towns began to see that a quaint green was good for tourism.

Today the green remains an important and sometimes controversial part of a town. In Amherst, New Hampshire, whose common is on the National Register of Historic Places, residents take pains to protect the green. "A while ago, there was an idea to have a weekly farmers' market on our green, and we got some resistance from the people who lived near it: They didn't like the idea of all that traffic," says Gary MacGuire, Amherst town administrator. "Then a rumor went around that the selectmen were thinking of abolishing the market, and darned if there weren't sixty people at the town meeting, ready to do battle to save it. The buzzword in planning these days is making 'town centers' to build community. We love the fact that we have a real one."

Indeed, nowadays one can hear summer band concerts at village greens from Naugatuck, Connecticut, to Houlton, Maine. You might head to the fair on the green in Newbury, Vermont. The name of the event? The Cracker Barrel Bazaar. Say hi to Eb for me.

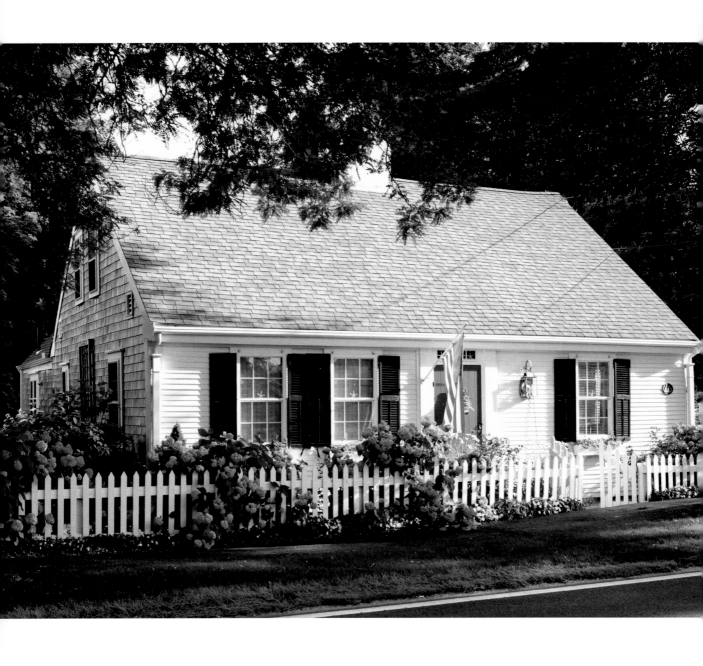

Cape Cod Houses

ASK AN AMERICAN CHILD to draw a house, and chances are pretty high you'll get a crayoned image of a Cape. The simple form is New England's gift to the collective consciousness, and the collective has rewarded it with what may turn out to be eternal life. Evidence of the enduring popularity of the Cape Cod house is everywhere, from the crank-'em-out versions of Levittown to the graceful midcentury interpretations by architect Royal Barry Wills to the little green houses we trade for hotels in Monopoly.

Funny thing is, no one is really quite sure whether the Cape originated on Cape Cod. There are very old—dating to the seventeenth century—examples of the style in Connecticut, on Massachusetts's Cape Ann, and in Maine. Some historians trace the style to stone cottages of a similar shape in Devon and Cornwall in the west of England, whence some of the earliest New England colonists hailed.

The Cape Cod house didn't get its name until 1821, when Timothy Dwight, a president of Yale, christened the type in his book *Travels in New England and New York*. "The houses in

Yarmouth are inferior to those in Barnstable," he opined, "and much more generally of the class which may be called with propriety Cape Cod houses." He goes on to describe a building instantly recognizable to any visitor today: "These have one story and four rooms on the lower floor, and are covered on the sides, as well as the roofs, with pine shingles, eighteen inches in length. The chimney is in the middle immediately behind the front door, and on each side of the door are two windows. The roof is straight. Under it are two chambers, and there are two larger and two smaller windows in the gable end."

Those gable windows caught the eye of Henry David Thoreau, who fancied that the various occupants in each Cape "had punched a hole where his necessities required it, and, according to his size and stature, without regard to outside effect. There were windows for the grown folks, and windows for the children—three or four apiece."

Behind his *bons mots*, Thoreau hits upon the essential nature of a house that seems to put its windows where they're needed and responds to its environment as practically as possible. Hugging the ground, with little or no roof overhang, sporting no fanciful trim, and anchored by a massive chimney dead center, an old Cape seems prepared to ride out any storm New England can throw at it. These houses have an ineffable homeyness, something sheltering and human-scaled, relating both to the natural surroundings and to the people inside. Wills, the Boston architect who is credited with deftly reviving the style in the 1930s, wrote in his 1941 book *Better Houses for Budgeteers* that the old Capes he loved are "as unpretentious as they are livable. Carping critics may poke fun at their rambler roses, picket fences and stately elms, but such things spell home to most of us."

For the early Cape builders, "home" meant an often surprisingly modest building. Capes are often ranked as half, three-quarters, and full, describing a house that could be expanded from a small building with a door and a pair of windows to its side, to one with an extra window flanking the door, to a larger symmetric home with the door in the middle. But Claire Dempsey, associate professor of American and New England studies at Boston University, points out that early descriptions of the style were subtly but tellingly different: house; house and a half; double. "To me, that means that the old-timers were happy to call that smallest building a proper home," she says.

When Wills started designing his revival versions in the 1930s, he imitated not only the massing and details of the originals but also the size. According to architect Stanley Schuler, author of *The Cape Cod House*, 250 years ago, the average Cape was about 1,600 square feet; Wills's early Capes were about the same. But by the 1980s, when Schuler asked Richard Wills, who had taken over his father's business, to point him toward some of the firm's recent work, Wills warned him, "You may not recognize many of them because they stretch for a hundred feet and more."

Nonetheless, many postwar Capes were—and remain—small. Sitting on larger lots, they often succumb to demolition, replaced by a supersize-me house. Those that remain, says Lexington, Massachusetts, real estate agent Bill Janovitz, can sometimes be a tough sell: "A full bath, often the only one in the house, on the first floor. One of the bedrooms on the first floor, too close to the action. Often challenged for ceiling height. Most people feel they want more of a flowing, open, spacious floor plan, which you can achieve more readily by adapting a ranch." Still, Janovitz says, "I grew up in a Cape, and they will always feel like home to me."

The Cape shall not perish from the earth—it's too much a part of the landscape, literally and metaphorically. Thoreau, as usual, put his finger on it: Surveying the range of housing stock, he saw the Capes as "more comfortable, as well as picturesque, than the modern and more pretending ones, which were less in harmony with the scenery, and less firmly planted." Which is why American kids will no doubt continue to draw Capes rather than McMansions.

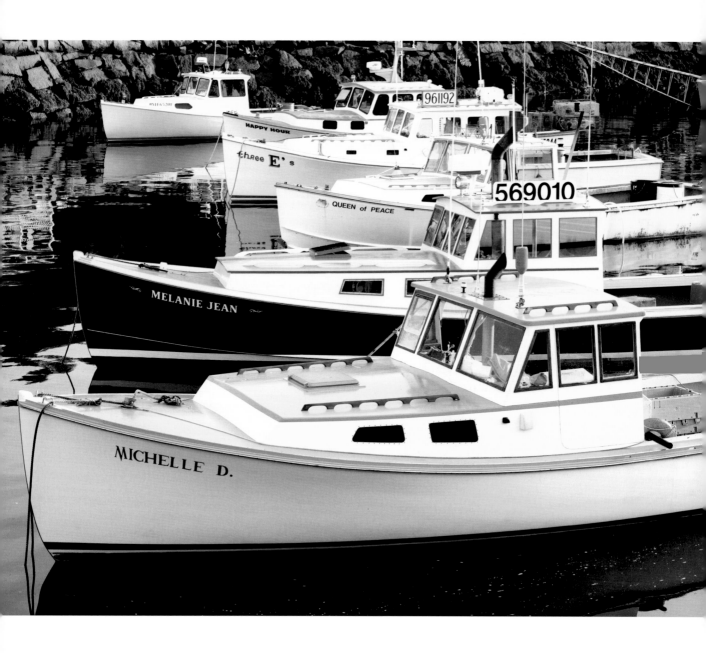

Lobster Boats

THINK OF THEM as the church steeples of the ocean, iconic New England shapes floating white and graceful in the early-morning mist of harbors and inlets. The lobster boat is a waterborne symbol of what it means to be from Maine, or certain parts of New Hampshire, Massachusetts, Rhode Island, and even Connecticut: independent, hardworking, connected to the sea, and with a certain no-nonsense stylishness that comes from practicality.

Early colonists in New England didn't need boats and traps and diesel fuel to put a nice lobster on the table. In the seventeenth and eighteenth centuries, the crustaceans were thick upon the ground, albeit under shallow water—the only tools needed were bare hands or, for the really big ones (some were reported to be five feet long), a gaff or spear. On Cape Cod, Myles Standish reported that after a good storm, lobsters would be piled a foot and a half deep along the water's edge.

Of course, all good things get eaten, and it wasn't too long until the days of easy pickings drew to a close. In 1812, Provincetown became the first town to restrict—to residents of the Commonwealth only—the taking of lobsters without a permit. By the middle

of the nineteenth century, men had to take to the sea to trap their quarry, and the first "lobster boats" were simply fishing vessels—rowing dories and sailboats such as sloops and ketches—that happened to haul lobsters. Since lobsters must be delivered to the shore alive (they spoil far faster than fish), the 1820s saw the introduction of the ingenious well smack—a sailing vessel with a large tank, or well, built directly into the hull. The walls of the well were five inches thick, with a central divider to cut down on sloshing and hundreds of holes cut in the hull to allow fresh water to circulate. Fishing themselves or collecting the catch of others, these smacks delivered lobsters to urban markets up and down the New England coast until the 1890s, when speedier steamships took their place.

Engines made their first appearance in the early part of the twentieth century—one-cylinder "make-and-break" engines like the one that old Bert Dow had in the children's story by Robert McCloskey. Dropped into dories and sailboats, these heavy, low-horsepower "one-lungers" didn't yield enough advantages to win over most tradition-bound lobstermen. It was quite a different story after World War I, when four-cycle, high-powered automotive engines became available. With ten times the horsepower-to-weight ratio of the old make-and-breaks, and the ability to be throttled and reversed, they proved too tempting to ignore. For lobstermen, speed meant more pots could be tended and more fishing grounds could be reached.

But their power and weight made the new engines a poor match to the old "full-displacement" boats the lobstermen were using. As Peter Kass, the only full-time wooden lobster boat builder in Maine, explains, "Full displacement means that the vessel can only go so fast—putting a lot of horsepower in one doesn't pay off after a point." What was needed was a new design, and boat builders from New England and Nova Scotia experimented until the handsome shape we all know became standard. It's a hybrid, with a V-shaped hull at the bow that flattens out as it makes its way to the stern. "A pure deep-V boat takes a whole lot of power to get up and plane," Kass says, "and it wallows at low speeds. A pure planing hull rises out of the water quickly, but big waves make it slam and crash. Lobster boats are 'semi-displacement'—they creep along fine when you're pulling pots, then plane when you hit the gas." A high bow fights off the rough seas, while low sides allow for easy trap hauling—connecting the two is the graceful sweep of the gunwale.

Kass, whose John's Bay Boat Company is in South Bristol, focuses lower, on the sheer. He calls this fore-to-aft line of the deck, seen from the side, "the most important line of a boat." He's prejudiced, but he prefers the sheer of a traditional Maine vessel, especially that of a so-called Jonesport or Beals Island boat, named for the way-Downeast towns where the design originated. Like most Maine-style boats, these have a low, continuous sheer, their deck curving without break from bow to stern. Nova Scotia–style boats, by contrast, have their wheelhouses pushed farther forward, with a bigger, flatter work deck aft, a step up to a raised foredeck, and a resulting stagger in the sheer line.

These basic types haven't changed much over the years, though fiberglass has almost completely replaced wood (Kass builds two boats a year) and boat size has tended to increase as engines have become more powerful. With legend placing its roots in Prohibition rumrunning, lobster boat racing is big Down East. Most summers, sanctioned races are held from Harpswell to Beals Island; in June 2010, Beals Island lobsterman Galen Alley set a modern lobster boat speed record of 68.1 miles per hour in his superlight *Foolish Pleasure*.

Kass builds both working boats and "gen-tlemen's" boats—traditionally shaped but tricked out with mahogany interiors, hot and cold running water, showers, and three-zone heat, they're also called "lobsteryachts." One such boat, the thirty-two-foot *Bernadette*, cost its owner three hundred thousand dollars. Bruce Norelius, of the Blue Hill, Maine, architectural firm Elliott Elliott Norelius, sees in this range "a wonderful metaphor for a shared aesthetic sense in New England. Rich or poor, we all see beauty in simplicity, and almost everyone enjoys it a little rough around the edges. They're sort of like the boat version of the Cape-style house: invariably humble on the exterior, while inside containing anything from modest to well-to-do families."

As for colors, white is traditional, with a red bottom, and no "boot top" or stripe at the waterline. "No good Yankee would waste time painting that," says Kass. Decks are a pinkish orange "buff," light gray, or "Newport green," like the bottom of a swimming pool—not too reflective and not too absorptive of the sun's rays. And boaters take note: Blue is bad luck. "I'm not particularly superstitious," says Kass, "but we built a blue boat a while ago and that thing has broken loose from its mooring twice."

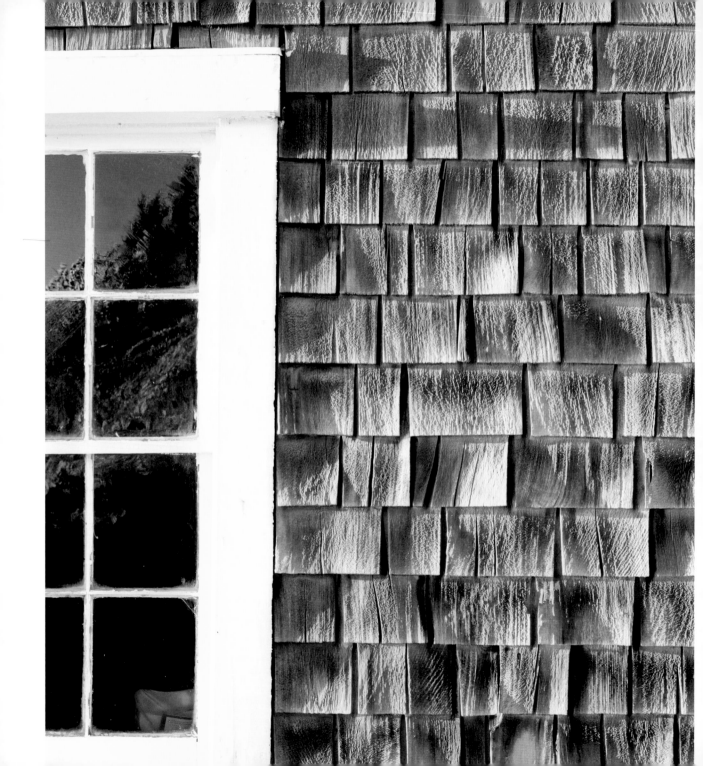

Wood Shingles

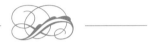

WOOD SHINGLES have long been a favorite way for New England house builders to keep inclement weather at bay. A part of European construction since at least the tenth century, shingles were embraced by colonists, surrounded as they were by the seemingly endless wood supply of the New World. Laid edge-to-edge, lengths overlapping, shingles covered roofs and walls with a water-shedding skin that also blocked the wind and came to define the look of early American buildings from the coastline to the mountains.

Still, centuries of wood shortages in the old country made for some habits that took a while to die in the colonies. English-style thatch was the roofing material of choice for the earliest settlers, though the ever-present danger of fire eventually led towns and cities to outlaw it. Its replacement by wood shingles was a dubious improvement, but wood was the best material that most people of modest means could afford, slate and tile being prohibitively expensive.

Shingles were fairly simple to make when using a froe, an L-shaped cleaving tool with a handle and a wedge-shaped metal blade. Positioned on the butt end of a short log and hit with a mallet, the

froe split the wood along the grain. Trimming the sides and ends with a drawknife resulted in a finished shingle. Size seemed to matter: In a sign of building codes to come, Massachusetts Bay decreed in 1695 "That all shingles exposed to sale, shall . . . bear eighteen or fifteen inches in length, and not under three and half inches in breadth . . . [nor] under full half an inch thick, and [be] well shaved."

All sorts of wood worked, including oak, chestnut, pine, and cedar. White pine was a favorite, as it's easily split and—because its branches (and therefore its knots) grow in a circle—has long runs of clear wood. Eastern white cedar, though knottier, gained favor for its longevity, based on its water- and rot-resistant closed-cell structure and high oil content. Brian Cooper, an old-house specialist based in Stonington, Connecticut, says, "I once relocated a house built in 1660 that had three-foot-long hand-split white-cedar shingles on its exterior walls, and they were in great shape after three centuries on the job."

By the time the ever-frugal Henry David Thoreau built his famous cabin at Walden Pond, wood had become scarcer and thus more dear. Of the $28.12½ he spent on materials in 1845, he allotted a generous $4 for shingles.

Though he purchased the cheapest "refuse" grade, they nonetheless were the second most expensive item on his list, and equal in price to the thousand salvaged bricks he bought to build his chimney.

As America grew, its citizenry demanded lots of shingles. New Englanders devised ways of harnessing the newly invented circular saw to the task of making them. By 1850, New Hampshire alone had five hundred water-powered sawmills manufacturing some thirty million shingles a year. With the advent of rail transportation, red-cedar shingles from the West Coast began to appear in the Northeast toward the end of the nineteenth century. In part, demand was driven by new architectural styles. Victorian houses, especially those in the Queen Anne style, celebrated millwork of all kinds, including eye-popping displays of shingles in multiple patterns, in fancy cuts with names like *arrow*, *diamond*, *fish scale*, and *half cove*, along with the more prosaic *diagonal*, *hexagonal*, *octagonal*, and *round*. In a reaction to such exuberance, the more subtle Shingle Style arose, with a nearly continuous skin of plain shingles covering and accentuating the structure's irregular massing from rooftop to foundation.

Though shingles remain intrinsic to the New England vernacular, sometimes to the point of cliché (Nantucket souvenir T-shirts read TAKE A LEFT AT THE HOUSE WITH GREY SHINGLES), few are produced locally. The majority of white-cedar shingles come from Canada, while red-cedar shingles are manufactured on the west coasts of both the United States and Canada.

Maine is home to a handful of mills, among them Dow's in Corinth and Longfellow's in Windsor. Dow's has been in operation, with a brief intergenerational break, since 1920, while Longfellow's is a relative newcomer, starting up in 1992. Jim Longfellow, who employs his wife, two daughters, and a son-in-law, likens his operation to David against Canada's Goliath.

"They're working the volume game up there—one Canadian sawyer can cut twenty-five squares [enough to cover twenty-five hundred square feet] a day," he says. "We're less mechanized and go slower, eight or ten squares a day, but we think our quality is better." As complaints have grown about the declining durability of all kinds of wood, cedar included, Longfellow has begun making a pressure-treated shingle that promises to last several decades up on a roof.

His most requested shingle size? "Sixteen inches long, no less than three and a half inches wide, with a half-inch butt." It's nice to know that things haven't changed much since 1695.

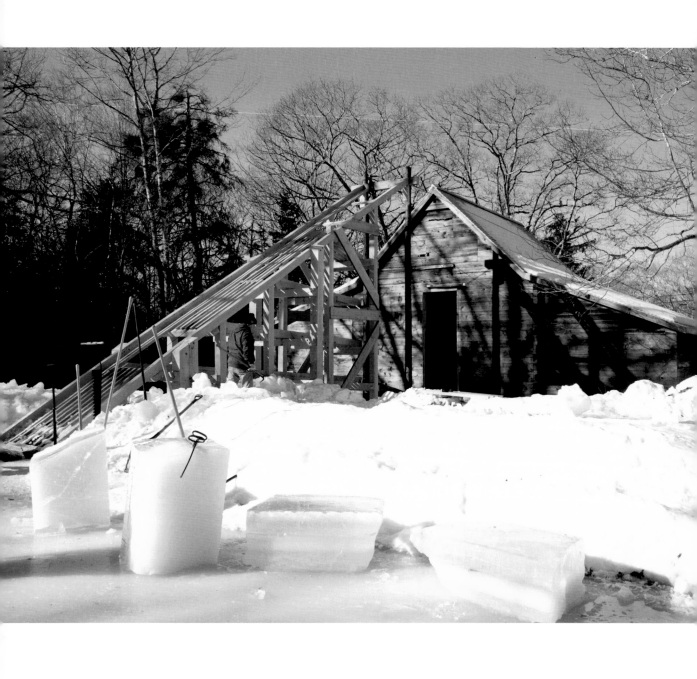

Icehouses

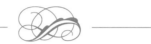

TAKE A WALK around Fresh Pond in Cambridge, Massachusetts, and you'll marvel that such a quiet, natural setting can be found so close to the bustle of the city. Strollers and bicycles are the vehicles of choice, and the only building you'll see is the city's water treatment plant, quietly filtering the pond's water for the use of residents. Squint a little, and you can easily imagine that you're in another century—but not the nineteenth, when bustle was a year-round phenomenon at Fresh Pond.

The reason was industry, and the industry was ice. Hundreds of men cut, hauled, stacked, and shipped huge "crystal blocks of Yankee coldness" to sweltering U.S. cities, the West Indies, and far-off India, a 130-day voyage. There was even an "Ice King," Nahant, Massachusetts's Frederic Tudor, who single-handedly invented the business of exporting New England ice. His (and his competitors') palaces were vast wooden and brick icehouses that studded the Fresh Pond shoreline. One was described in a local newspaper as "nearly as large as the storehouses erected by Joseph, in Egypt, for grain." At 40 feet high, 178 feet wide, and 199 feet long, and with 4-foot-thick walls, it could hold thirty-nine thousand tons of ice.

Yet all that remains of this multimillion-dollar enterprise is a lonely historical marker on busy nearby Concord Avenue, where few pedestrians pass.

The Fresh Pond ice business was but a large-scale example of a long-standing New England cottage industry. Farmers harvested ice from their ponds for the community's use, storing the frozen fruit of winter in purpose-built cellars or aboveground houses of wood, brick, or stone. In a time when the intricacies of thermodynamics were still being worked out, common sense mixed effectively with science. Journals, almanacs, and early U.S. Department of Agriculture pamphlets described methods of insulating buildings, the main strategy being hollow stud walls packed with sawdust. Peaked roofs were vented along the ridge for warm air to escape, with thick ceilings to fight back the summer heat. It was also understood that assembling the biggest cube of ice possible would ensure a slower melt, so blocks tended to be stacked solidly together, with an extra layer of sawdust tamped between them and the insulated walls.

These blocks were not to be trifled with. Harvesters waited until the ice was at least a foot thick, and preferably thicker. Not only was a thick piece of ice slower to melt, but the thicker the ice on the pond, the less likely a horse, an important part of the team, would fall through. The width and length of blocks varied by market—twenty-two inches by forty-four inches was a standard size, and at fifteen inches thick, that was five hundred pounds sliding down the chute from the elevator into the ice-house. In "A Day on the Ice-Field," an 1894 essay in *Demorest's Family Magazine*, a Lake Champlain icehouse foreman got to the heart of the difficult work of stacking ice "cakes." "Put Samson himself up there on that staging for the first time," he remarked, "and tell him to spread himself on those cakes, and I'll venture he'd ask for an unlimited vacation after half an hour's work, besides busting half the cakes, barking his own shins, and smashing the toes of everybody around."

Commercial or private, the wrestling of ice was a seasonal rite in New England. Yet if the mighty edifices at Fresh Pond (as well as many other commercial ice centers) have disappeared, what are the chances that humbler buildings still survive in the age of man-made ice and the electric refrigerator?

Pretty poor, it turns out. When the need for natural ice passed, so, too, did the usefulness of

places to store it; wooden icehouses, by far the most common, proved to be the most perishable as well. Still, along with the older generation's memories of iceboxes and the iceman, a few New England icehouses linger on, some even continuing their work of keeping crystal blocks from melting in the summer heat. Vermont museums, such as Billings Farm in Woodstock and the Justin Smith Morrill Homestead in Strafford, have original icehouses and historical exhibits. Ice harvesting is an annual event at the Floating Bridge on Sunset Lake in Brookfield, Vermont, and at the Remick Country Doctor Museum and Farm in Tamworth, New Hampshire, where ox-drawn sleds still carry the blocks to the icehouse.

Perhaps the fullest history lives on in South Bristol, Maine. Ken Lincoln has been working the ice on a farm pond in town since he was a kid in the 1960s. He was the last owner of the commercial ice operation there, closing it in 1985. In 1990, it was reopened as the Thompson Ice Harvesting Museum, resurrecting a 165-year-old winter ritual. Every February, ice is harvested and stored in the restored icehouse; on the Sunday closest to July 4, Lincoln and fellow volunteers use the winter bounty to make ice cream the old-fashioned way, at a "social" open to all. Thompson ice is also much sought after by the yachting crowd. "They'll haunt me for two or three days to get a big block," Lincoln says, adding that with less air entrained, natural ice is denser than man-made and melts more slowly. "Two foot by two foot by eighteen inches—that'll last a good week out on the water."

At Rockywold-Deephaven Camps on New Hampshire's Squam Lake, the lake's ice is as important today as it was for folks in the nineteenth century. Fittingly for a retreat founded in 1897, the camps' cabins have iceboxes, serviced by an iceman who pulls blocks from two icehouses that are stocked each winter by a hardy band of employees. In 1967, the camps bought a bunch of modern refrigerators; they were rejected by campers and ended up in staff quarters. The Ice King still has some loyal subjects.

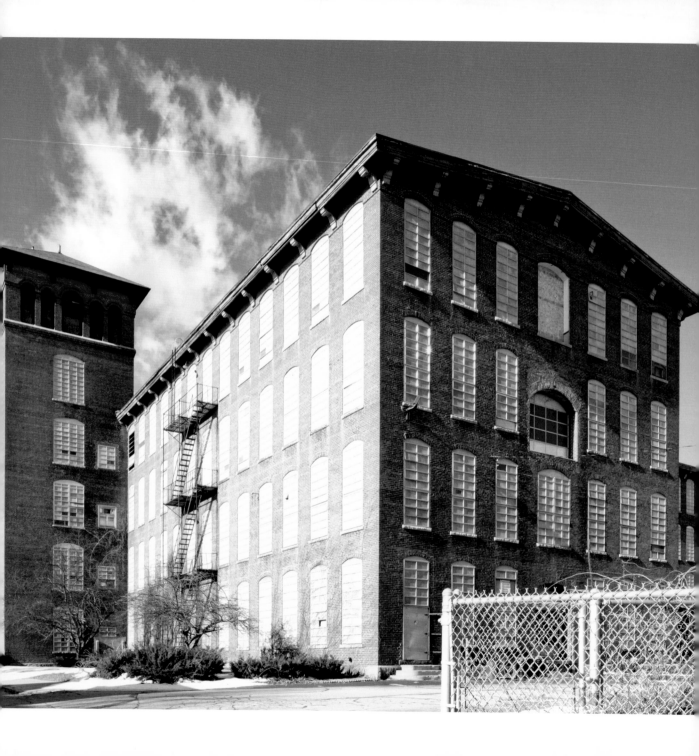

Mills

THEY ARE THE SLUMBERING GIANTS of New England: massive mills that once hummed with activity and now, for the most part, lie still along the waterways and main streets of cities, towns, and rural hamlets.

Early New England was solidly agricultural. What industry existed served a farm-based economy, with small mills grinding corn, cutting lumber, and forging tools. Everything else, like cloth, came from Europe or was made at home. Still, though men planted flax and raised sheep, and women spun the resulting fibers into thread and yarn, the citizenry spent more of its money on foreign-made textiles than on any other imported goods.

All that began to change in 1790, when Samuel Slater, an Englishman armed with manufacturing know-how, came to Pawtucket, Rhode Island, to help Americans Moses Brown and William Almy set up the young country's first cotton spinning mill. The rushing waters of the Blackstone River powered the building, a simple wooden structure two and a half stories high, forty-three feet long, twenty-nine feet wide, with a pitched roof and a belfry from which the workers were called. Its heavy timber frame, with a single row

of posts running down the center and floors open from end to end, housed spinning machines powered by long wooden shafts that connected to a waterwheel. Abundant light from long rows of windows allowed workers to tend the machines more safely. Slater's Mill, which has been preserved as a museum, was imitated far and wide. By 1840, seven hundred similar factories were scattered across New England, the region's abundant streams and rivers providing the power, workers from played-out farms and from overseas providing the labor, and, curiously, the cool damp climate creating ideal conditions for cotton fibers to strengthen as they were spun into thread and cloth.

Over time, wood exteriors gave way to masonry, which was less prone to catch fire, but the change also reflected a cultural shift. Early sawmills, gristmills, forges, and the like were modest in style and stature; these stone-and-brick mills were something new, something more important. They sent a signal that industry deserved the same respect as civic and ecclesiastical institutions. They said that, once and for all, Americans would be independent of Europe, and these temples of manufacturing reflected that growing pride.

Ironically, the villages that grew up around the mills, especially those in rural locations, reflected a kind of manorial paternalism reminiscent of Europe's Middle Ages. They owed their existence to the factory and the man who owned it—hardly a beacon of democratic ideals.

At the same time, they were not the "dark Satanic Mills" of poet William Blake's England. Aware of the stigma that manufacturing had developed for debasing the working class, owners took care to make conditions appealing, especially as they sought to attract the daughters of Yankee farmers, a large pool of labor that came cheaply and in abundance. "Factory girls" worked twelve-hour days, six days a week (for about $2.50), which kept them out of trouble. Their spare time was taken up with mandatory church attendance and other supervised activities.

Waltham, Massachusetts, was the site of the first major corporate mill operation, the Boston Manufacturing Company, founded by Francis Cabot Lowell and his associates. Built in 1814 on the Charles River, it comprised two huge four-story brick buildings that turned raw cotton into one finished product—white sheets.

After Lowell's death in 1817, his associates

named the new town they built on the banks of
the Merrimack River, near Chelmsford, Massa-
chusetts, for him. By 1833, Lowell was home
to ten textile companies employing six thou-
sand workers. It became the model for cities
like Lawrence and Fall River, Massachusetts;
Willimantic and Hartford, Connecticut; Man-
chester and Nashua, New Hampshire; and Saco
and Biddeford, Maine.

The big brick mill buildings of the mid-
1800s—four to six stories, usually with flat
roofs, long rows of windows, and an external
stair tower—were utilitarian boxes built with
one thing in mind: maximum production. Since
fire was an ever-present danger, the interiors
featured "slow-burning construction," with
beefed-up beams and posts allowing for wider
spacing and less exposed wood; four-inch-thick
wood floors also slowed the spread of fire. But
even large corporations have vanity, and many

of the boxes were adorned with architectural
flourishes, sometimes along cornices and almost
always at their stair towers and cupolas. Perhaps
the most famous of these is the star-spangled
blue Moorish dome of the Colt firearms factory
in Hartford. For fancy stair towers, it's hard to
beat the mansard-roofed octagonal confection
at the Continental Mill in Lewiston, Maine.

Today New England as textile titan is a
long-faded memory, and its many old mill
buildings need new uses or risk destruction.
Lowell is perhaps the most successful model of
factory reinvention. "Lowell maxed out at
about five million square feet of factory floor,"
says Charles Parrott, architect at the Lowell
National Historic Park. "About half of it sur-
vives today, and we're seeing 85 to 90 percent
of that being converted to office and residential
space. After years of neglect, people now see
the value in these buildings."

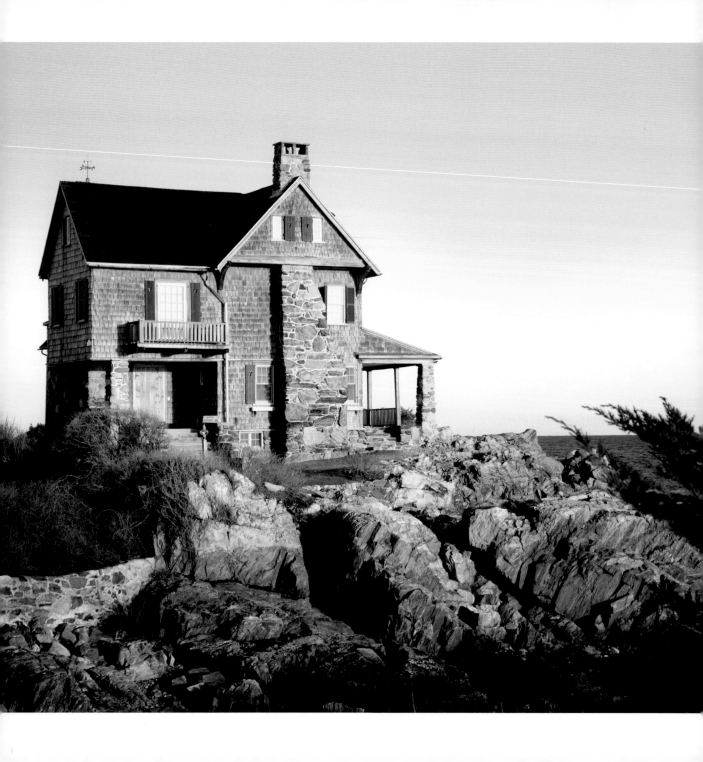

The Shingle Style

RENOWNED ARCHITECTURAL historian Vincent J. Scully Jr.'s definitive book on the Shingle Style is aptly titled *The Architecture of the American Summer*. Relaxed, informal, and comfortable, the Shingle Style produced houses with names like Breezyside by the Sea, Breakwater, Wave Crest, and Seacroft. They dotted the turn-of-the-century New England coast, capturing the essence of the new leisure class and sending out a very American declaration of architectural independence.

High style and beautiful, the Shingle Style was the first truly homegrown American architecture. Its creation coincided with the formation of the first real class of professional architects in the country, and many of them (notably H. H. Richardson, William Ralph Emerson, John Calvin Stevens, and the firm of McKim, Mead & White) embraced the genre.

Their buildings were "innocent of ornament," as the historian Margaret Henderson Floyd put it, nearly free of the fretwork and flourishes, the ornate columns and pilasters of preceding architectural styles. Dark-stained shingles stretched over irregular massing, often with a colonial saltbox roofline added somewhere, the taut

skin giving a snug, unified feeling. Rough stone foundations made the houses look as if they sprang naturally from the living rock, and interior layouts were open and flowing, unlike rigid Victorians with their receiving parlors and sitting rooms. Entry halls were wide and welcoming, their staircases handsome, broad, and easy. Porches were deep-set, roomy, and cool. Sometimes floors would rise and fall from room to room, as if mirroring the irregular earth below. And since these summer houses were usually unheated, the shingles were a practical way to accommodate the expansion and contraction of the wooden frames through the changing seasons.

Born in New England, the Shingle Style was, at its heart, a reaction against the decoration and European-ness of Romantic and Victorian architecture. Each in their turn wildly popular in the States over the mid- to late 1800s, Gothic Revival, Italianate, French-derived Second Empire, medieval-inspired Stick, and olde English Queen Anne all shared genes that led back to the Old World.

But as the centennial of the American Revolution approached, a sense arose that the country was moving too fast, had turned urban and hard, had become corrupt and overly sophisti-cated compared with the simpler times of 1776. There was a renewed interest in colonial architecture, and writers grew nostalgic for its better features. "The halls are wide and deep," wrote T. B. Aldrich in an 1874 *Harper's Magazine* article titled "An Old Town by the Sea," about houses in Portsmouth, New Hampshire, "after a gone-by fashion, with handsome staircases, set at an easy angle, and not standing nearly upright, like those ladders by which one reaches the upper chambers of a modern house."

By 1876, when the Centennial Exhibition, attended by ten million visitors, opened in Philadelphia, the stage was set for a full-throated embrace of national roots. And those roots were in New England, where hearty Englishmen—and pointedly *not* recent immigrants from Eastern Europe or Ireland—had built their houses on the shores of a wild continent. It was the rugged simplicity of those structures, tightly shingled against the elements, to which architects now turned for inspiration. The new style was a merging of the Queen Anne (deemed acceptable for its English historicity) with humble materials such as shingles and stone that symbolized simpler, more democratic times.

Which isn't to say that these new houses

were not large and grand—anyone able to commission an architect to design one would likely be more of a plutocrat than a democrat. But at least the rich could seem, and maybe feel, less highfalutin in the comfortable, shingled "cottages" they built along the New England seashore. The Shingle Style was a resort form, and though some houses were built in established towns like Brookline, Massachusetts, and New Haven, Connecticut, they were far more common in eastern Long Island, Newport, Cape Cod, and the coast of Maine.

Driving home the point that this was hardly an everyman's architecture, many of the most beautiful Shingle Style buildings weren't houses at all, but secondary structures: stables, laundry buildings, gatehouses, coachmen's and gardeners' cottages, icehouses, and even bowling alleys built on large estates. There were country clubs, yacht clubs, casinos, fishing and shooting clubs, chapels, and a few exclusive hotels as well.

Since their 1880–1900 construction heyday, Shingle Style houses have developed a devoted following, especially among architects, perhaps because relatively few were built (high style comes at a high price). Robert A. M. Stern, for one, has made a career out of resurrecting the style for a moneyed clientele. But it's not just the pros who seek to duplicate them. One of the most iconic Shingle Style houses of all, Kragsyde—built in 1882 in Manchester-by-the-Sea, Massachusetts, and torn down in 1929—captured the imagination of one couple, Jane Goodrich and Jim Beyor, who a hundred years after its construction began building a replica on Swans Island in Maine. Using original plans they'd discovered in the Boston Public Library, they took twenty years to complete Kragsyde II. An American original reborn, it has the signature summertime feel, but this incarnation has heat.

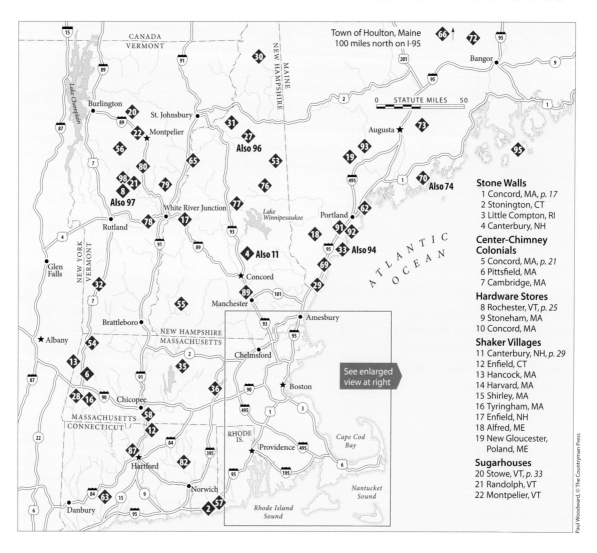

The sites shown here are those existing locales mentioned in this book. Use them as a starting point; you will no doubt find your own favorite iconic sights along the way.

Garden Cemeteries
23 Cambridge, MA, *p. 37*
24 Plymouth, MA
25 Jamaica Plain, MA
26 Boston, MA

Grand Hotels
27 Bretton Woods, NH, *p. 41*
28 Stockbridge, MA
29 New Castle, NH
30 Dixville Notch, NH
31 Whitefield, NH
32 Manchester, VT
33 Kennebunkport, ME

The Forest
34 Groton, MA, *p. 45*
35 Petersham, MA
36 Worcester, MA

Roof Walks
37 Nantucket, MA, *p. 53*
38 Salem, MA

Modernist Communities
39 Lexington, MA, *p. 57*
40 Lincoln, MA
41 Concord, MA
42 Belmont, MA

Skating Ponds
43 Weston, MA, *p. 61*
44 Cambridge, MA
45 Jamaica Plain, MA
46 Boston, MA

Saltbox Houses
47 Concord, MA, *p. 65*
48 Hamilton, MA
49 Quincy, MA

Church Steeples
50 Groton, MA, *p. 68*
51 Topsfield, MA
52 Wellesley, MA

Classic Ski Areas
53 North Conway, NH, *p. 73*
54 So. Williamstown, MA
55 Roxbury, NH
56 Waitsfield, VT

Armories
57 Westerly, RI, *p. 77*
58 Springfield, MA
59 Boston, MA
60 Somerville, MA
61 Portland, ME

Village Greens
62 Lexington, MA, *p. 81*
63 Naugatuck, CT
64 Amherst, NH
65 Newbury, VT
66 Houlton, ME
67 Boston, MA

Cape Cod Houses
68 Brewster, MA, *p. 85*

Lobster Boats
69 Ogunquit, ME, *p. 89*
70 South Bristol, ME

Wood Shingles
71 Woods Hole, MA, *p. 93*
72 Corinth, ME
73 Windsor, ME

Icehouses
74 South Bristol, ME, *p. 97*
75 Cambridge, MA
76 Tamworth, NH
77 Holderness, NH
78 Woodstock, VT
79 Strafford, VT
80 Brookfield, VT

Mills
81 Woonsocket, RI, *p. 101*
82 Willimantic, CT
83 Waltham, MA
84 Lawrence, MA
85 Fall River, MA
86 Lowell, MA
87 Hartford, CT
88 Pawtucket, RI

89 Manchester, NH
90 Nashua, NH
91 Saco, ME
92 Biddeford, ME
93 Lewiston, ME

The Shingle Style
94 Kennebunkport, ME, *p. 105*
95 Swans Island, ME

Add'l photo locales:
96 Bretton Woods, NH, *p. 2*
97 Rochester, VT, *p. 6*
98 Hancock, VT, *p. 8*
99 Pepperell, MA, *p. 110*

Paul Woodward, © The Countryman Press

109

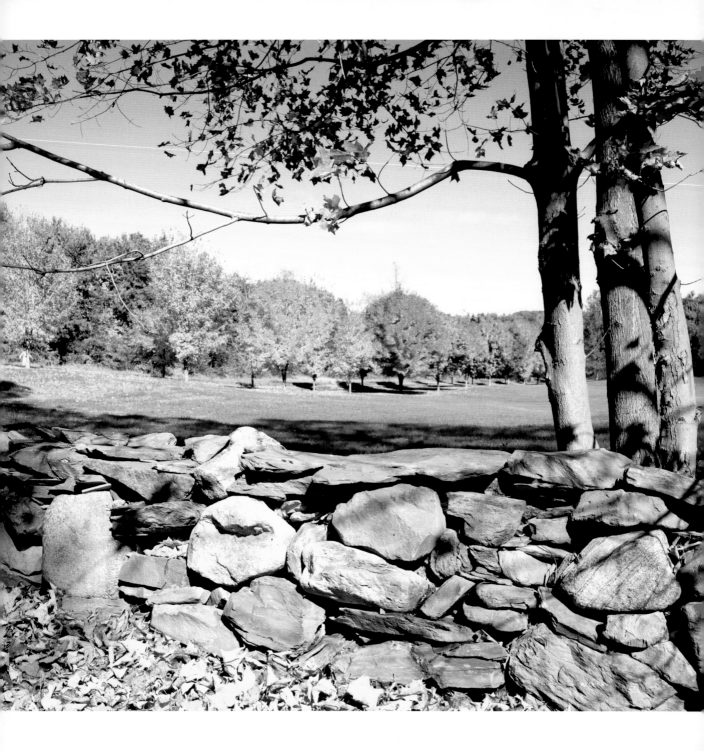

CREDITS

The essays in this book were originally published in *Design New England* magazine.

"Stone Walls," January 2007.

"Center-Chimney Colonials" was originally published as "Center Stage," September–October 2010.

"Hardware Stores" was originally published as "Supply and Demand," September–October 2009.

"Shaker Villages" was originally published as "'Tis the Gift to Be Simple," May–June 2009.

"Sugarhouses" was originally published as "Sweet Simplicity," March–April 2010.

"Garden Cemeteries" was originally published as "Here on Earth," March–April 2008.

"Grand Hotels" was originally published as "Ladies of Leisure," July–August 2008.

"The Forest," March–April 2007.

"Fireplaces" was originally published as "Good Fires for Good Living," November–December 2008.

"Roof Walks," May–June 2007.

"Modernist Communities" was originally published as "Bauhaus in the 'Burbs," September–October 2008.

"Skating Ponds" was originally published as "Ice Capade," January–February 2008.

"Saltbox Houses" was originally published as "Let's Renovate, Said the Colonists," September–October 2007.

"Church Steeples" was originally published as "Steeple Chase," November–December 2007.

"Classic Ski Areas" was originally published as "Ski Areas, Lost and Found," January–February 2009.

"Armories" was originally published as "Armed and Ready," May–June 2011.

"Village Greens" was originally published as "Common Ground," July–August 2007.

"Cape Cod Houses" was originally published as "The Ever-Enduring Cape Cod House," May–June 2010.

"Lobster Boats" was originally published as "In Praise of Lobster Boats," July–August 2009.

"Wood Shingles" was originally published as "Shingles, Tried and True," January–February 2010.

"Icehouses" was originally published as "When Ice Was Hot," July–August 2010.

"Mills" was originally published as "The Mighty Mill," January–February 2011.

"The Shingle Style" was originally published as "All-American," March–April 2011.